THE
PAUL HAMLYN
LIBRARY

DONATED BY
THE PAUL HAMLYN
FOUNDATION
TO THE
BRITISH MUSEUM

opened December 2000

TECHNIQUES
OF TERRACOTTA

TECHNIQUES OF TERRACOTTA

Quentin Bell

ILLUSTRATED BY
JULIAN BELL

CHATTO & WINDUS

THE HOGARTH PRESS
LONDON

Published in 1983 by
Chatto & Windus / The Hogarth Press
40 William IV Street
London WC2N 4DG

BRITISH LIBRARY
CATALOGUING IN PUBLICATION DATA
Bell, Quentin
Techniques of terracotta.
1. Terracotta sculpture – Technique
I. Title
738.8'028 NB1265
ISBN 0-7012-2664-7 (hardback)
ISBN 0-7012-2701-5 (paperback

Text Copyright © Quentin Bell 1983
Illustrations Copyright © Julian Bell 1983

Printed and bound in Great Britain at
The Camelot Press Ltd, Southampton

Contents

[5]

Figures in the text

The Glossary/Index
also contains drawings.

[7]

Introduction

It is not at all an easy thing to find an efficient title for this book. By an efficient title I mean one which will define the kind of sculpture about which I feel qualified to write and, at the same time, give a notion of the kind of advice that I have to offer.

The sculpture with which I am concerned is made out of clay, the kind of clay which, when made into plates or cups, is described as earthenware and which, in its sculptural form, is called terracotta. Almost all sculptors use clay, even though they may eventually translate their works into bronze, marble, stone or other materials. Clay is in fact a sketching material of three-dimensional art; it is used, as paper and pencil are used, rapidly and conveniently to give shape to the artist's ideas. It can be used in a very intimate fashion for, although there is nothing to prevent a clay model from being very highly finished, it can also receive, and in a very permanent way retain, the artist's slightest intentions or the most sweepingly rapid of his statements. Thus clay is frequently used to express the artist's first thoughts concerning something which may eventually be embodied in a more expensive and prestigious material. Very often we find that the terracotta modello (or sketch) is more lively and more expressive than the finished marble.

The kind of terracotta sculpture of which I shall write has the technical character of the modello; the artist is restrained by only two structural considerations: the object must be able to stand up while he is making it and it must be so made that it can be fired in a kiln and receive the hardness and durability of brick.

Casting, which is a form of printing in the round, can be used to make any number of identical terracotta figures. The amateur who wishes to do this will need to comply with structural restrictions of an exacting kind and to learn some quite different

techniques. It is a process which has not interested me and of which I know too little to write with authority. I shall do no more than glance at the techniques of reproductive terracotta; nevertheless there are some very simple casting processes which may be of use to anyone working in this medium, and these shall be discussed as fully as is necessary.

Porcelain is a material which presents possibilities and difficulties different from those of terracotta. The making of porcelain figures is again something of which I cannot speak with expert knowledge and concerning which I can offer no advice.

In calling this book *Techniques of Terracotta*, I must therefore make it clear from the outset that I deal with a fairly narrow area of sculpture. The kind of person for whom I am writing has been attracted by this wonderfully versatile and responsive medium; he is attracted by the many technical possibilities of clay as opposed to porcelain, he or she does not want to produce wares *en masse* for the market, he or she may be interested by the idea of using colour, and will want to begin by using very inexpensive processes. For such people I have, I hope, a good deal of useful information and good advice, some of which might be of interest to those who are no longer students and perhaps to studio potters.

I imagine my readers, or at least the great majority of my readers, in one of two situations: they are attending classes in ceramic art or, better still, are employed in someone's workshop; or else they are entirely on their own and hope by using this book to teach themselves. Both situations have their disadvantages; those of the solitary worker are obvious and it is he or she who will suffer most acutely if, at any point, I fail to make my meaning perfectly clear. I accept the challenge that their situation imposes, knowing very well how hard it is adequately to describe in the pages of a book those processes which are so easily demonstrated in the studio. The solitary worker will have been obliged to find some place in which to work; it may be a very humble workshop indeed, but at least it will free the student from the temptation to rely upon the weekly lesson in a well-appointed studio with every

modern convenience. Too often such students, when once the course is finished and they find themselves reduced to the very simple apparatus with which, usually, the beginner must be content, are completely disconcerted and fatally discouraged by the change of scene. For both therefore it is useful to receive advice concerning very simple and very inexpensive methods of working. For the student who already has a teacher it may also be an advantage to receive alternative advice. We all have our own methods, and the student should be in a position to consider and compare different injunctions from which he may choose that which suits him best.

It will be clear from my title that I am concerned only with techniques. It has been said that art cannot be taught, and this is true inasmuch as we can supply the means by which genius may express itself, but we cannot supply genius; nor would I be so bold as to assert that there is any 'right way' of making sculpture. This statement may appear to be contradicted by my use of images and illustrations, for although I do consider the peculiar technical problems which arise when we attempt to create those regular inorganic forms which have been so popular in the art of the past seventy years, I do also accept the terminology of those sculptors who, from the earliest times, seem to have been mainly interested in organic and indeed in human shapes. This is a matter of convenience. Consider the following statement: 'Working in moist clay it is not easy to support a mass upon a slender column the diameter of which is, at one point, no greater than one tenth of that of the mass that it carries.' It is much easier to say: 'Working in moist clay it is not easy to make the model of a man standing on one leg.' Both statements describe the same kind of problem but the one is shorter and more readily comprehensible than the other and because the problems are so much alike, if you can deal with the one you will know how to deal with the other.

I include a chapter on teaching methods which is largely based upon the observation of organic forms and of the human figure, and here I do not hide my sympathy with methods which have

been in use since the Renaissance. But again it may truly be said that he who has mastered the problems which arise when we represent the human figure in clay will be well equipped to do whatever he pleases.

The plan of this book

This book is intended as a straightforward guide for those who are interested in making terracotta sculpture and, like most other books, should be read from cover to cover. The last section which I describe as Glossary/Index has more the character of a work of reference. It is not only an index of tools and other impedimenta and a glossary of terms, but also a means whereby the student can turn at once to the section or sections which concern him. With this end in view the rest of the book, apart from Chapter I, which is argumentative rather than instructive, is divided into fairly short sections and these, where it seems useful, have been furnished with cross-references, the numbers of cognate sections being given in brackets.

1 *Teaching and learning*

The techniques of those who teach sculpture are rather different from those who actually make it. I do not mean to imply, in saying this, that the teacher should not also be a sculptor; in fact I think he or she should at all events have had some experience as a modeller before instructing others in the use of clay. Here we enter an area of discussion in which there are much greater differences of opinion than there are concerning practical matters and in which it is much less easy to know whether I am right or wrong. Moreover, some readers may differ from me, not because they question the efficiency of the methods that I propose but because, when it comes to education, they have aims different from mine.

It is proper that I should begin by stating my aims: I do not think that art educationalists are people who expect to rear men and women of genius. If genius comes our way we hope that we may give it every chance of developing; probably the best that we can do is not to stand in its way. Our main concern is with human happiness; we want to teach people to enjoy both the creation and the contemplation of sculpture. You need very little talent in order to get enormous pleasure from working in terracotta, or in other media. You need practically no talent at all in order to gain an added pleasure from looking at the sculptural work of others.

For children, direct sculpture (i.e. carving) is likely to be difficult; there are practical and in some cases psychological obstacles. But modelling in clay is easy. Most children learn, or ought to learn, a little about drawing. They will find opportunities in the primary school and soon discover what a delightful thing it is to paint a picture; their pictures are duly praised and pinned up on the wall. They may be kept for a time but in the end they will almost certainly be torn up. Their models made in clay and fired

are in the same way praised and exhibited but they are not easily destroyed; indeed they tend to go home, there to adorn the family mantelpiece. It is the first indication that sculpture is, for the child, a more 'serious' art than drawing. There is something momentous about making 'a thing', particularly if that thing be as solid and as imperishable as a brick; the thing exists in a way that most pictures do not; it has the quality of a toy, a doll, an image which may be imagined as having a life of its own as most pictures have not. Also, in an elementary, but to the child a quite real, sense, it is likely to be a better thing than a drawing. For the image on a flat surface, vast though its imagined possibilities may be and superior, as it certainly is, as a vehicle for narrative or for drama, must, as the child grows up, appear increasingly childish and therefore inept.

Children don't much care for child art and, as they encounter adult work, which usually means the work of the advertiser or the illustrator, they care for it even less; the sheer virtuosity of the adult artist, the ability to create the illusion of volume upon a flat surface, the kind of realism which challenges the achievements of the photographer himself, disconcert and overwhelm us, putting us out of patience with our own clumsy unschooled efforts; we attempt to vie with adult competitors and failing, lose all stomach for the fight.

We all of us know, for it has become enshrined in our national iconography, that portrait of Lord Kitchener scowling and pointing his finger directly at the spectator and telling him to enlist. Many of us have observed the dexterity of the artist who could achieve so sharp a foreshortening of the arm and hand. Vasari felt much the same about Michelangelo's fresco of Jonah on the ceiling of the Sistine Chapel. Confronted by such prodigies, we despair of our own talent.

But the situation of the young modeller is different; his work belongs much less to the commerce of everyday life; he has no rivals on the printed page or in the media, and for him the miraculous reproduction of solid forms upon a plane surface is an

irrelevance; he deals not in illusion but in reality. In a sense, then, the work of the modeller is 'easy', or at least it is less concerned with technical or aesthetic problems from which he is not diverted by questions of illusion and verisimilitude.

This being the case, it seems to me that the teaching of children in this medium should be largely technical and at the same time, from the point of view of representation, ambitious.

Let me explain my meaning by means of an example (§10). Suppose a child wants to make a model of a bull. There are those who would encourage it to model in clay a schematic figure which is in fact a solid version of the kind of 'stick' figure which the child draws in infancy: that is to say the child is bidden to make eight rolls of clay, one for the head and body, one little one for the tail, four for the legs and the other two for the horns. If you make the body sufficiently slender and the clay is sufficiently tight, the object will stand up; but the child knows that it doesn't look like a bull and indeed that the characteristic thing about a bull is the great mass of its thorax and the comparative delicacy of its legs. What it wants is to be told how a model of a bull can be made which will stand on its own four legs. As readers of this work will discover it is a very simple business (§12) and, once learnt, the child is free to work as he pleases and to work in the knowledge that his sculpture may be fired. Children, in my experience, want to know about techniques and most of the techniques here discussed are well within their range. Once they have been learnt, the child can be free to examine the more interesting possibilities of sculpture, and although what follows is intended primarily for the art student I think that there is much that an entertaining teacher might consider suitable for adaptation to the art room.

Modelling is not drawing. This simple truth should, I think, be impressed both upon students and children. It is also true that much drawing has an affinity with modelling and the painter is often concerned with the problems of the sculptor; his is, when all is said and done, a wider and more adventurous form of art; but

there are sculptural problems which can only be solved in terms of sculpture.

Our first concern is, I think, with the rotundity of objects. I believe this to be true despite the fact that there are some eminent sculptors who, in their work, seem to deny this, compressing the bulkiest forms into wafer-thin silhouettes; but it seems to me that the value of such works lies very largely in their deliberately unexpected quality. We are interested in two-dimensional sculpture precisely because we take it for granted that sculpture will be three-dimensional.

Nevertheless the Giacometti cut-out figure shares, and indeed emphasises, one of the characteristics of all free-standing sculpture; true, we are given flatness where we expect bulk, but the fact remains that the sculptor can never see all of his work at the same time. Here, in fact, we come to one of the main differences between the two arts when considered from a pedagogic point of view. The painter sees and draws what he sees. There may indeed be occasions when his teacher has to remind him not to draw that which he 'knows to be there' but cannot in fact perceive. That dark mass in the background may be a bush or it may be a bear, to the impressionist it makes no odds; it is simply a dark mass. But although the expressionist may be justified in going beyond the facts and doing his utmost to suggest that in truth it is a bear, the art student will probably be advised, and well advised, to stick firmly to his impression.

The possibility of such a choice hardly exists for the sculptor. He is obliged, almost at once, to describe that which he cannot see. That which the painter perceives, and may indeed render simply as a flat disc must, if such be the facts of the matter, be rendered by the sculptor as a sphere. He is obliged to state what he knows, if necessary in defiance of that which he sees. He must be ready, in imagination at all events, not merely to look at but to handle that which he describes; and whereas it is impossible to imagine a blind painter there have been blind sculptors.

This rather special method of receiving information should, I

[18]

think, be brought to the attention of the tiro and some initial exercises should be devised with this end in view. If I mention one or two possible methods for the beginner it is not because I have found them so valuable that they could not be improved or diversified with other exercises, but because I do not recollect seeing them in use in schools of general education or in schools of art.

To begin with, I would suggest that the draped still life might prove a valuable exercise for the young. The still life is itself a useful theme for the student, if only for the practical reason that it stays still and is easily available for the solitary worker. The still life can make us aware of shape in a forceful way. A still life of apples, the shapes of which at once remind us of spheres, but which soon confront us with all sorts of modifications and irregularities, might be associated with or preceded by a still life of tennis balls, where the perfect sphere is only modified by the pattern of interlocking and interwoven shapes upon its surface. From this it is but a step to the draped apple, that is to say the object contained within a sheet of paper, tin foil, satin, corduroy, cloth dipped in slip, or whatever the imagination may suggest, to show how each enveloping material shows its own structure and, with varying tensions, its own systems of folds.

This exercise can be made even more interesting (but here the solitary worker must call in a friend to help him) by draping an unknown object, the form of which may be more or less clearly apprehended beneath its envelope. The student gains an added understanding of drapery (and remember that drapery has fascinated sculptors in China, Chartres, Athens and Rome), and an added interest in the shape of a thing which is not perceived but divined.

The 'Feel Box' provides a purely tactile sensation; here again one needs a friend or a teacher who will place objects in a box or a bag. The student putting in his hands can feel but cannot see that which he attempts to model or to draw. It is important here that the concealed objects should be unrecognisable. The shape of a

[19]

shaving brush or a revolver will be too easily remembered, and the point is to give no information save that which comes from touching an irregularly shaped stone, a piece of wood or chalk or dried clay, or whatever may give no clues to the memory of the student.

One further example may be mentioned because it takes us away from the mere development of haptic abilities and into the area of appreciation and history. The student is shown a photograph of a free-standing figure, preferably a work that he has never seen before but which belongs to the *oeuvre* or the period of a sculpture which he knows well. The photograph is of course taken from one point of view, the object being that the student must invent those parts that he cannot see, or rather he must infer the whole from the evidence of a part. The visible areas give him a number of clues, his knowledge of other work by the same hand or the same school will also assist his invention. Like the other exercises here suggested, this is intended to teach the student to go beyond that which he can actually see, but here he may be assisted by natural taste and a knowledge of art history. Also, if a photograph of the missing areas is available, or if the student can see the original, he can discover how nearly he has approached the intentions of the master.

To this I would add that the mere business of working from art, that is to say of imitating another man's work, can in itself be a most exhilarating exercise. Copying has a bad name, but it is in truth one of the most illuminating forms of criticism. The copyist can perceive as the mere spectator cannot, unless he be very highly trained, the problems and the solutions of his predecessor, an artist whom he comes to know with an affectionate familiarity which is not to be gained by any other method.

Having said so much I will go on and risk an even graver accusation of being 'reactionary' by suggesting to the student that he should choose as his subject a piece of sculpture far removed from the aesthetic of our own period. The natural tendency of the student is to be preoccupied by questions of style, and the danger

of copying is that we tend to acquire a master's style rather than to understand his intentions. If we study that which is remote in time or in culture, there is little risk that we shall become mere imitators. It is those who consciously, or what is even worse, unconsciously, produce pastiches of modern work who become copyists in the bad sense of the word, imitating the manner rather than learning to understand the virtues of those whom we study.

The style of the moment, the fashionable form of art, is indeed a most seductive thing, and almost any visit to a school of art will show us plenty of examples of young sculptors who have learnt to express themselves in the idiom of the moment, sometimes quite brilliantly, but who have learnt little else. Their tragedy comes when they have graduated and find, as find they must, that the idiom has changed and that they themselves have discovered nothing to say. To some extent this is understandable, pardonable, and virtually inevitable. The student cannot but be excited by the latest fashion. The important thing is somehow to give the young a taste for work of a kind which is so remote from the fashions of our day that its faults and virtues can be considered without prejudice, that is to say, without the irrelevant qualities which we find in the work of yesterday or of today, work which we either reject or accept on stylistic grounds.

It was in fact the fault of the academies that they were schools of taste, a taste based on what was thought to be a Hellenic model – the Farnese Hercules, the Medicean Venus – which models, when they came to grief, brought the academies down with them. But the modern art school, by exalting one shibboleth at the expense of another, hardly improves matters. All over the country high-minded art school principals broke up their collection of casts under the impression that they were striking a blow for freedom; all that they did was to deprive the student of examples for which they are now beginning to feel a need and which cannot be replaced. The cast was destroyed because it had been a teaching prop of the Renaissance; in the same way, because it was a traditional engine of instruction, the model was

'sacked'; here I am happy to say the revolution has not been so complete, for it could be far more disastrous.

The art of sculpture, far more than the art of painting, has been concerned with the human body, although the manner in which that sentiment has been expressed has varied enormously from place to place and from time to time. There seems a prima facie case for supposing that the sculptor of the future will want to go on using the model, even though it may serve only as a starting point. That this extraordinarily rich source of observation and study should continue to be provided for those students who may need it, seems to me to admit of no doubt at all.

The late Walter Sickert was very much opposed to the use of the nude in our art schools. Like so much of his teaching, it made excellent sense within the context of his own work. A clothed model was much more to his taste because, as sculptors know to their cost, drapery once disturbed can never be accurately restored. The artist was accordingly obliged to throw himself impetuously at his subject knowing that what he was seeing would not be seen again, working therefore at a high pitch of excitement which, if you happened to be Sickert, would produce a very spirited drawing. But if you are a sculptor, making a model of that which you see, it is necessary that the pattern of folds should be observed, not from one angle but from many. No model on earth can hold one pose long enough for all its aspects to be noted, however roughly and rapidly, while the revolving throne turns through a semi-circle.

For the sculptor, then, the nude is a far easier proposition than the draped figure, and the student who wants to study the draped figure will probably model from the nude and then, having recreated the pose, drape the clay model (which can hold its pose for ever) and work from that. The alternative, which consists in taking a series of photographs, is also useful but many will prefer the older method.

These notes have been composed with the amateur in mind and it is impossible to ignore the fact that the study of the model,

whether nude or draped, is not easily undertaken. It demands space, it demands warmth and, ideally, the services of a model who is capable of sitting still. It is possible though, to begin in an unambitious way; it may not be too hard to find someone who is willing to sit on a piano stool while you make a clay model of a head and neck. As you become more adept and more ambitious you may beg, buy or construct a revolving throne and, perhaps with the collaboration of friends, employ someone who is ready to take easy poses in the nude.

The effort is worth it, and this despite all that may be said against it. You may be told that the nude is itself a cliché composed of a multitude of clichés, that it is an outworn theme, that those of us who extol it as a teaching instrument do so only because we ourselves were taught in the life room and therefore have all the pedagogic tricks at our fingers' ends. And yet, when we actually set to work, extraordinary though it may seem, our first impression always is one of astonishment. Here, we feel, is something entirely new. There is something in the construction of human beings which fills one with amazement. Nothing is more intensely alive than a nude, nothing more sculptural, nothing more satisfying to shape, nothing gives a more enduring satisfaction. I speak for myself, but not only for myself, I think, when I say that there is no more rewarding occupation than work from the model. Even on a bad day, even when you are making a mess of things, it is impossible not to feel as the clay takes shape and captures a suggestion of the beauty of the subject (in sculptural terms any model is beautiful), it is impossible, I say, not to feel that this is one of the best things that life has to offer.

CLAY

1 CLAY NOT DEFINED

It would bore you and bother me to attempt to describe the chemical composition of clay.

For our purposes it will be sufficient if I say that clay is stuff that you can dig out of the ground. There is a vast quantity of it just below the surface of the earth. In its natural state it can be mixed with water and if you stir it about for long enough it will become so liquid that you may easily pour it through a sieve. When moist it is plastic and will contain water; as it dries it hardens and changes colour; when cooked it becomes quite hard, cannot be mixed with water and may become as hard and harder than a brick. Terracotta (the Italian for cooked earth) is a term that we do not use in speaking of bricks, or indeed of fired earthenware; it is a term used exclusively for fired clay sculpture and for a certain shade of red.

Until it receives a final and immutable form in the kiln, clay is continually changing. It dries, solidifies, shrinks; wrap it in a wet cloth and it will again become plastic; from being a kind of water it develops into a sort of slush; then, in drying, it becomes first like cream, then like butter, and then as solid as putty and a wonderful medium for modelling. While you are modelling it, unless you arrest the process by spraying it with water, covering it with a damp rag or enclosing it in polythene, it stiffens and becomes 'cheese-hard'; thereafter it becomes 'chalk-hard'; fire it and it becomes a kind of soft brick; at higher temperatures it becomes as tough as stone or glass; at very high temperatures it may liquefy for a time. These changes vary according to the composition of the clay and the way in which it is treated.

Generally speaking the modeller is likely to prefer a tighter (i.e. harder) clay than the potter. Some writers on sculpture assume

that all the modeller's work will be done at the stage when he can work his clay easily with the fingers or with a wooden tool, but you will find that there are processes which are better undertaken when the clay is hardening, when it is chalk-hard or even when it has been fired. At these stages obviously you will need abrasive tools or perhaps a knife. Of the so-called 'cold clays' which harden without being fired or need only to be put in a domestic oven, I can say nothing. For purely aesthetic reasons I have not used them and I can say nothing of the problems and opportunities that they can offer. These are not to be confused with the highly refractory clays mentioned in the next section.

2 **BODIES**

The word 'body' is used for a clay which is or has been made suitable for the ceramic worker. Clay can be dug from the ground in a variety of colours ranging from pure white to deep red. The commonest clays used in making terracotta are 'blue' clay, which is of a slate-grey colour and, when fired, becomes first pink and then a warm shade of yellow, and red clay which usually becomes redder.

An earthenware body is likely to contain impurities and in all probability iron will be one of these; it is the iron which gives the body its characteristic reddish colour. Clay tends either to be plastic or, as they say, 'short'. If it is too plastic it is hard to model, if it is too short it will not model at all. But such extremes are rare. There is a very wide range of clays which are reasonably plastic and perfectly well suited for the making of terracotta figures or earthenware pottery.

Almost any clay will shrink as it dries (usually it will lose about a tenth of its volume), and one of the first things that you need to find out about a clay is the extent of shrinkage and whether in the process it tends to crack. One of the advantages of buying a prepared body is that the maker will be able to tell you about the character of his clay in this respect. If you are working on a small scale, that is to say making objects which are no more than 3in

(7·6cm) thick, you will probably not have to worry about the effects of shrinkage. But a large lump of clay shrinks in upon itself and the water inside it (there is always water even though the object appears to be quite dry) will not escape. This will lead to cracking or to an actual explosion in the kiln. This means that unless a piece is quite small it is much wiser to make it hollow, and this remains one of our principal concerns in the whole business of clay modelling (§11).

3 FROM WHENCE SHOULD YOU GET YOUR CLAY?

If you have a garden there may well be clay beneath your feet, and you may feel that it is a pity not to use it or at least to make tests with sample quantities of it. In this case consult §5. On the other hand, it is likely to save you a great deal of time and trouble to buy your clay from a shop; it is not very expensive and when you first begin you are unlikely to need very large quantities. A hundred-weight bag of moist prepared clay should keep you going for months (§§4 and 5).

4 SHOP CLAY

If you get your clay from a shop it will certainly have been purified and contain no rubbish (this is not always the case if you buy from a local pottery). Also you can ask your dealer for a clay suitable for modelling in terracotta. He will sell you a clay that contains refractory materials, probably consisting of some very fine sand or 'grog'. (Grog is earthenware ground up exceeding fine.) A clay which has in this manner been fortified is, in the opinion of some, pleasanter to use than are other bodies, and it is much less likely to crack when fired, or to distort.

Prepared clay usually comes in a plastic bag which of course must be carefully fastened when not in use. Although there are obvious advantages in purchasing the material in its lightest and powdered condition, I would advise you to buy it moist. It is surprisingly difficult to moisten dry clay so as to get it conditioned for modelling, and the business of wedging the clay (§9) becomes more important and more prolonged.

5 CHOOSING A CLAY

Choosing a clay is like choosing a husband or a wife. Look around for the body that suits you and will meet all your needs. Make careful tests to see what happens to the clay under various conditions and then, when you have made your choice, stick to it and admit no other body into your studio. To have more than one clay in your workshop makes an enormous amount of work and waste.

Shop around if you like. Go to several different firms and ask them to provide sample quantities of the various bodies that might be suitable, until you discover which one you find pleasantest to handle.

At this stage it will be a great advantage to have the use of a kiln and to be able to fire your clay at different temperatures.

Make your samples on tiles, for you will want to model the clay in such a way that it will break easily. Then make samples which will test the strength of the clay severely. The sample should be made with a waist or link which will be likely to break either in drying or in firing (fig. 1). If the sample remains intact it will tell you just what liberties you can take with the body. It may take you a little time to devise a form which is a fair test and does not impose too impossible a strain on the sample.

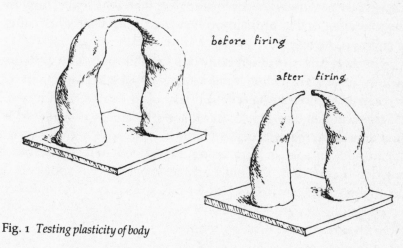

before firing

after firing

Fig. 1 *Testing plasticity of body*

6 YOUR OWN BODY

If you have a fine vein of good-looking clay at the bottom of your garden and an aspiring soul within you, you will very likely reject all shop-made pre-prepared ceramic bodies and make your own body. I do not recommend this, but there are people who enjoy the preparation of clay as much as they enjoy modelling it and to them I offer the following advice:

Take a spade, dig down at least three spits deep and take a handful of clay from the bottom of the pit you have made. Some clay will crumble in your hand when you squeeze it and this should be rejected. Dig several pits and make a sample from each, having first washed the clay (§7) and wedged it (§9).

Ideally, clay that you have dug yourself should be weathered. The Chinese, I am told, used to weather their clay by piling it in a great circular shape in the open. From one extremity of the unfinished circle, that which had weathered longest, they withdrew their clay for immediate use, at the same time adding as much clay as they had taken to the opposite extremity of the pile. Thus they always had clay that had been left to weather by their grandparents and at the same time were constantly making provision for their grandchildren. The difficult thing about this arrangement is to know how to begin.

For your purposes I would suggest that you leave clay to weather (i.e. to be broken up by frost and heat and cold) throughout the winter.

If you find that your own body cracks in drying, or distorts in the kiln, try adding a little very fine sand or grog to strengthen it. For certain purposes I have found that quite coarse sand mixed into the clay will be suitable, but it is not generally considered a good modelling material (§26).

PREPARING THE CLAY

7 WASHING CLAY

If you use a clay which you have yourself dug out of the ground, or if, in the ordinary course of working, you find that you have clay which has dried up or been in some way wasted, or if you have clay which has been dirtied with foreign matter, as is almost bound to happen when you use clay in mould-making, then you will need to wash it, i.e. to pass it through a sieve; not a fine 'lawn' or potter's sieve, but one of sufficiently fine mesh to capture grains of coarse sand.

This can be a wearisome process unless the clay be made so liquid that it will pass easily through the mesh. Very liquid clay is quite easily purified; but of course it takes up a lot of space so that you will need what may seem a disproportionately large container for the job.

In fact I would suggest, if you are doing a lot of work with clay, that you should obtain two dustbins with lids to prevent foreign bodies from entering. Put all your dirty clay into one, mixing enough water in it to make a very watery body. Then pour the slip (liquid clay) through a sieve into the second bin and let it stand (fig. 2a). After a day or two the clay will have sunk to the bottom leaving pure water above (fig. 2b). Draw off the water, being careful not to disturb the liquid clay below, and pour it back into the first bin where it can be mixed with whatever clay may remain after the first process and can then be poured back through the sieve. As you repeat the process you get more and more pure sieved clay in the second bin. This you can use as slip or you can dry it out and use it for modelling (§36).

8 SLIP

As has been said, slip is liquid clay, but you will find that some slip is much more liquid than other slip and that it tends continually to solidify. You can help it to do this by removing surface water. Also, if you have a large bin of slip you will find, as

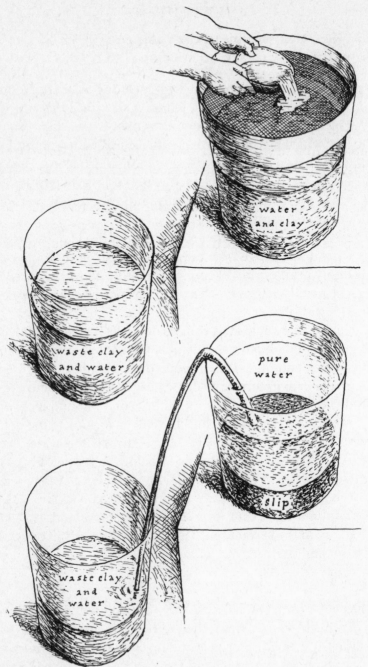

Fig. 2 a *Sieving impure clay;* b *Siphoning water off slip*

you might expect, that the thickest material is at the bottom. For most purposes it is best to use slip which is of about the consistency of double cream. You can make it by the method described above (§7) or by taking a handful of clay and manipulating it in a bowl of water until it reaches the consistency that you want.

Slip (slightly thinner than that here described) can be used in casting (§33). Slip also makes an excellent pigment and will take various colours (§18).

Slip makes an admirable ceramic glue and you will find that you need it all the time when you are modelling. Roughen the surfaces that are to be joined, treat them with slip, and you have a strong bond. I find that in making very small additions to a model, a dab of slip at the point where the addition is to be made is sufficient.

Don't pour slip down the sink or let it go into your drains. It blocks them up (§43).

9 WEDGING

Wedging is the process of preparing clay for use by making it more elastic, homogeneous and pure. If you can use your own home-dug body you must wedge it very thoroughly; if you buy prepared clay you may be less thorough. The modeller, in particular, may be satisfied with a quite summary process. Potters tend to consider the process with something like mystical awe; also they use an oriental method which, for your purposes, is unsuitable. Personally I devote scandalously little time to the wedging of prepared clay if I am going to use it for modelling. I have an uneasy feeling that this is wrong, but so far as I can see I suffer in no other way for my laziness. But you must wedge thoroughly if you are using recycled clay, or if the clay has a lot of air bubbles in it or impurities of any kind.

If the clay is too loose (soft) for your taste, work on an absorbent surface such as plaster. Wedging will always make clay a little tighter, whatever surface you use.

To wedge a lump of clay you need: a clean surface, a length (say 12in, 30·5cm) of fine wire with toggles (bits of wood, fired clay, paper or whatever) tied to its extremities in order to give you a good grip, and a 'loop' or some other tool with which to extract any impurities (fig. 3a).

Let the lump of clay be as big as you can comfortably handle, the bigger the lump the better the wedge.

Cut the lump in half, raise one half as high as your shoulders or higher and bring it down in silent fury upon the other half (fig. 3b).

I use the words 'silent fury' because the operation should be very energetic but, as far as possible, quiet. When the upper half strikes the lower half it should never make a smacking sound, for a smack tends to create an air bubble (just what you want to avoid). The upper half should be brought down, not directly from above, but with a glancing blow, at an angle so that it tends to pull the lump towards the wedger (fig. 3c).

Your object is to mix the clay. Therefore with each operation new surfaces should be joined, for obviously if a surface that has been cut with the wire is reunited with the opposing surface from which it has been divided, the clay remains more or less as it was. You can obtain a greater degree of mixture by varying the cut. Supposing your lump were the shape of a sausage, then, if your first cut sliced the sausage from end to end and the two halves were reunited in such a way that the sausage shape were maintained, the second cut should go through the shortest width of the sausage and be reunited in such a way that the clay would have more or less the appearance of a tinned loaf of bread.

You may test the efficiency of your wedging by working with clays of two different colours. For a modeller's purpose it will be sufficiently wedged when the whole thing is of one even hue. I think you may be surprised by the speed with which this can be done. I have found that I can get an even colour after fifteen operations, whereas many potters are not happy until the clay has been cut and rejoined at least one hundred and forty times.

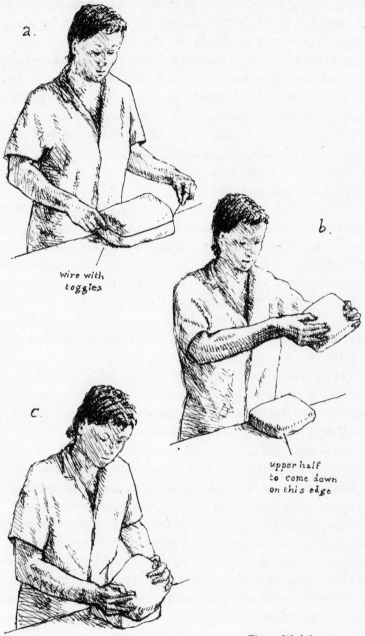

a.

wire with
toggles

b.

upper half
to come down
on this edge

c.

Fig. 3 *Wedging*

With each cut that you have made, look for impurities which you can take out, or air bubbles which you can squeeze out. If it is a really dirty or bubbly bit of clay, there is nothing for it but to go on wedging until the clay is clean. But the sculptor will usually find, and can easily remove, impurities from his work, particularly if it is on a small scale. His main worry is inequalities of texture, and these will also be done away with by wedging. If you have to mix clays of different consistencies, you will see little bands of soft clay rippling through the firmer body, and so long as you can see them, go on wedging; but it will not take you very long to remove them.

A minor point: when you have become proficient you will find wedging a tedious business. You may turn on the radio or think of something else and thus easily lose count of the number of times that the clay has been wedged and perhaps give yourself unnecessary work. It is worth finding something numerable, dead matches, beans, lumps of fired clay or what you will, and moving them from place to place. You soon find that you can count without thinking while you continue to listen to the chat programme.

When clay has been wedged it is ready to be modelled, in fact any clay can be modelled when it has ceased to be so sticky that it will adhere to the tool or to your fingers and when it is not yet so hard that it will break under pressure. But you will discover as you work that there is an ideal condition, ideal that is for your purposes, or rather you will discover that there are several ideal conditions for your methods are likely to vary as the clay hardens, becoming less plastic but more responsive in other respects.

Probably you will want to arrest or even to reverse the drying process so that you can come back to your work after a long interval. You can soften a clay model by draping it in a rag which has been made wet and wrung out. You can arrest the drying process by enclosing it in polythene. If it is possible, enclose both the clay and the model on which it stands in a bag, otherwise the base of your sculpture will dry out while the rest stays moist.

[34]

EXERCISES

10 PRELIMINARY EXERCISES

Begin with small objects. Something no thicker than a grape will give you no trouble, but if it is as large as an orange it may well present technical problems. This may seem a severe limitation, but after all a tile 12in (30·5cm) square may be thinner than a grape, and so might a snake with an extended length of two yards. In fact you would be wise to accept a further limitation and to keep all your dimensions on the small side; you might find a 6in (15·2cm) tile surprisingly large, and if your snake extended for more than 12in (30·5cm) you might have trouble getting it into the kiln.

It is because large masses, masses more than 12½in (31·8cm) thick, are likely to give trouble that many text books suggest that you should begin by making animals or people composed of rolls of clay, the plastic equivalent of the 'stick' figures of small children. For reasons which I discuss in my first chapter, I would suggest that, unless you have a consuming urge to produce sculpture of this kind, you should look for something else. You may very likely want to begin by making geometrical shapes; this again may suit some students but, if you hope to achieve geometrical regularity, you are attempting something rather difficult (§13). Another genre which may attract the beginner is the low relief (a high relief might involve you in technical difficulties). Work in low relief is so close to drawing that you may find it a natural first step towards sculpture; if your work has representational character it may involve you in some rather difficult problems (§1), but technically this makes an excellent beginning. If you want to go straight to purely sculptural problems, that is to say to the representation of rotundity, of that which cannot be represented on a plane surface, then I would suggest that you find a suitable model in nature: a fruit, a nut, a snail shell or your own hand (somewhat reduced).

Working, as you almost inevitably would, on a rather small

scale, you may wish again to disregard the advice of many authorities and use some kind of tool rather than your own fingers. You may have the tool you need, but if you do not you can fashion something with a penknife and a piece of wood that will suit your purposes very well.

The production of small models will give you a first under-standing of your material, and because they are small you will not have to worry about shrinkage. The models can be allowed to dry, reworked if you like at later stages, and fired.

There is one technique which, although probably unnecessary at this stage, should be practised because it will develop a good habit. When you want to join two pieces of clay, even though it be a very small addition to your model, use slip to make the join (§8). This sounds a tedious business, but in fact the habit is soon acquired and is unconsciously performed; when you come to larger objects it may save you from disaster.

Probably you will want to go from these small projects to something rather larger as soon as possible. It is more interesting and in some ways easier to work on a larger scale, but you will encounter two problems: shrinkage and support.

11 SHRINKAGE

This is the main technical problem that confronts you. Most clays, if they are shaped in a mass as large or larger than your clenched fist, will shrink so much and retain so much water that it is dangerous to fire them as they are; they must be hollowed out. It has already been said (§2) that there are prepared bodies offered for sale which make the danger of a kiln accident very much smaller, and clearly it is worth seeing whether there is a clay which will suit you and which can be very freely used. Everything that follows will be affected by the character of your clay in this respect. But I am assuming that you will use a clay that must be treated with care.

You may find it a good plan to make a clay ruler. This is simply a piece of clay with a straight edge on which, while it is moist, you

have marked your inches or whatever measurements you may use. Don't make it longer than 6in (15·2cm) as a longer rule might warp in firing or in drying and falsify your measurements. Dry it, fire it and see what happens to your 6in (15·2cm). It may well be useful in later calculations.

There are several ways of making a clay model safe to fire. Here I will discuss two methods, neither of which involves the use of a plaster cast (for which see §§28–34).

You can fashion your sculpture in such a way that it is hollow from the beginning by using a method which potters employ in making large vessels. Make long rolls of clay by rolling them out on any wide flat surface and trying to keep them of even width. Starting at a central point, lay the coils in concentric rings until you have formed the base of your model. Then, using the same method, build up walls of clay until you have formed the shape that you want (fig. 4).

Fig. 4 *Coiling clay rolls*

As you work, paint the sides of your rings with slip (§26) and, using a wooden tool, work the clay in each ring into its neighbour so as to make a more or less flat and uniform wall of clay. Unless the model be very small, and this method is usually employed for large pieces, you will need to make internal walls of clay to hold the shape together; also if you use loose clay, which is the most suitable for amalgamating one roll with another, a point may come when you have to pause and allow the lower portions to solidify a little so that they may be strong enough to carry the clay

above. It will probably be a good plan to 'stuff' your model as you build it up.

Stuffing can be almost any material which is at once strong enough to hold your forms in place and resilient enough to give a little beneath the pressure of the shrinking clay. Hay, straw, newspaper or, for fine work, lavatory paper, will serve as stuffing. I use newspaper and find that it works very well. I have seen polystyrene mentioned as a good form of stuffing. I have not found it so when used by itself.

In theory any form can be made by 'coiling' a shape. I have tried it with large figures but, whether the fault be mine or whether it be inherent in the method, always without success. I think it might work if you want a very simple rotund shape and had very carefully worked out the details before touching the clay. I find it difficult to control the profiles to my liking and very difficult if, in working, I want to make large changes. But there are those who have used the method and find that it serves them well.

Excavation is very much simpler. Imagine that you have made a model of an apple, and have reached the stage at which the general shape is sufficiently stated but the detailed work, if any, is yet to come. The clay is becoming a little bit tighter. You cut it in half with a wire as neatly as you can (fig. 5a), hollow out the two halves, stuff them, roughen the exposed edges of clay with a tool, apply slip and join them together again (fig. 5b). If possible, work the clay of the two halves across the joint that you have made, so that the opposing pieces are united; otherwise there is a danger that a crack will appear in firing along the joint. It is not hard to learn to do this so smoothly that the joint is invisible and the whole mass completely welded together (figs. 5b, 5c, 5d).

When the process is complete you will have trapped a pocket of air inside your clay. Hot air expands and could break your model, but the tiniest vent will allow it to escape.

If you have an armature (next section) in your model the business of excavation may not be quite so easy, and it certainly is a great help if the armature can be kept very simple. With a little

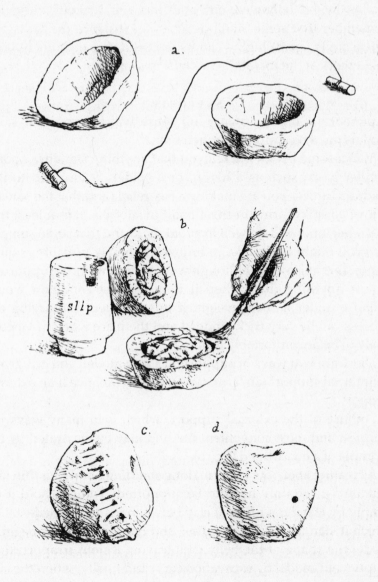

Fig. 5 *Hollowing out and backing.* a *Hollowed out apple form;* b *Packing and applying slip;* c *Binding clay across the joint;* d *Completed apple with vent*

practice you will find that quite large and quite complex shapes can easily be hollowed out and will fire without difficulty. Remember that some small details – for instance the arms of a figure 9in (22·9cm) high – can be left solid. For obvious reasons begin work at the top of the model if it is large.

12 SUPPORTS

Experience and your own good sense will tell you that some models must be supported when moist.

In fact some books will tell you that anything standing upon a slender basis, such as a heron, or a spider, is unsuited to this medium (unless you are making a bas-relief) and that the same is true of all spiky, arms-in-the-air sort of subjects. It is at least true that a beginner will do well to avoid them and that some subjects that you might undertake in bronze are barely possible or quite impossible in clay, for although we may find ways of supporting almost anything that, when it is in a moist condition would collapse under its own weight if unsupported, the drying out process can be very tricky indeed and the piece when finished is likely to be uncomfortably brittle.

There are two ways of supporting a clay model: you can give it an internal support (an 'armature'), or you can give it an external support.

The use of the external support, which is in many ways the simplest and most convenient method may be illustrated by the example of a quadruped (fig. 6).

A creature about 6in (15·2cm) long standing upon four thin legs will almost certainly need to be supported. You can hold it up simply by leaving a mass of clay between it and the pedestal on which it stands. As the clay dries and hardens you can begin to model the shape of the belly, still leaving a stout support, then empty your model by excavation (§11) and finally, when the clay is strong enough, you can remove the support altogether and finish off the treatment of the belly.

If the legs are so slender that you think that this may be unsafe,

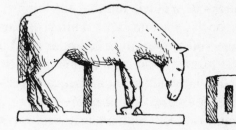

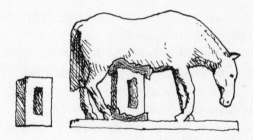

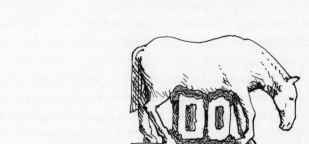

Fig. 6 *Supporting a quadruped*

you can remove the support in sections and, as each section is finished, put in a fresh piece which will be protected at each end by a few thicknesses of newspaper (fig. 6). The model can go with its support into the kiln; it will have shrunk a little and the newspaper will have fired away so that the entire support can be removed when the piece comes out of the kiln.

You will find that some modellers supply a supporting piece and leave it, disguised perhaps as a tuft of grass.

Exterior supports of another kind are sometimes used when modellers make, say, a figure with an outstretched arm (fig. 7a). These simply consist of a stick with a lump of clay at one end on which the projecting member rests, and a much larger lump to anchor it at the base. Supports of this kind rather tend to get in the way when you are modelling, but so long as the clay is reasonably soft you can cut off an arm or a head or anything which does not contain an armature, work on it while it is still workably soft, and stick it back again.

Any long columnar figure, particularly if it be one which is designed to carry a considerable weight of clay, is going to need an internal support or supports.

Some armatures illustrated in books are quite complex and form a kind of wire skeleton within the model. If the object is to be fired you should try for something much simpler, for you will almost certainly need to withdraw the support before the model is quite dry, otherwise the clay will crack up upon it.

In a small model which does not need to be hollowed out, you can meet this difficulty by wrapping your armature in several thicknesses of paper so that the contracting clay hardens upon a yielding mass (fig. 7b). The piece can then be fired with its armature inside it, or alternatively, when the clay is hard enough you can, very carefully, withdraw the support from within. (You will not be able to do this if the clay is in contact with the armature itself.)

For larger pieces, where there is a considerable weight of clay, a good stout support will be needed. Here you can excavate the clay

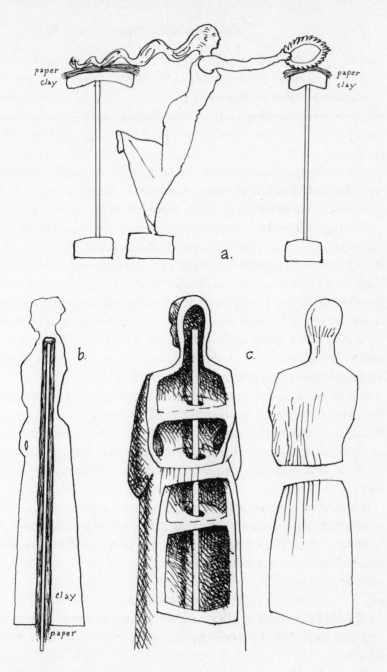

Fig. 7 *Supporting standing figures.* a *Props for outstretched model;* b *Section of small model;* c *Excavated large model*

and in so doing release the support; your stuffing will act as a sufficient support for the shell of hardening clay. In doing this, leave some internal members of clay so that your excavations form internal 'storeys' within the model. A large model completely hollowed out could easily prove too weak and too liable to distortion.

Try to keep the armature as simple as possible, one solid upright shaft of wood or metal should be sufficient (fig. 7b, c). For other methods of building in a support see §37.

It is possible, when the work is finished, that you will want to have some kind of plinth on which it can stand, and very likely the design of this plinth will form a part of the design of the figure itself. A plinth of wood, of plaster or of cement, perhaps with a member that will project up into the model, can quite easily be made and may be furnished with a 'mat' of baize or foam rubber or some other protective substance which will keep it from scratching other surfaces. Such a plinth may also be used as an armature while you are working on the model.

If you make your plinth and your figure all in one, remember that a massive plinth supporting a tall upright figure does tend to break away in drying or firing. It is safer, before the clay hardens, to separate the two and to join them again after firing. This would apply also to a quadruped supported upon four rather delicate legs.

It is convenient, in a workshop, to have a certain number of wooden or plaster stands, working plinths so to speak, which will be made with a thin vertical support of wood or stiff wire and will be available for use when wanted.

13 CHALK-HARD CLAY

As the clay dries out it will probably change to a lighter colour; it will lose weight and become very fragile. It is when clay is in this condition that visitors to a pottery pick up a quite solid-looking plate, taking the rim between finger and thumb, and find that they have taken a piece out of it.

At this stage it is best to keep your model on a tile or a kiln shelf or something else which will resist the heat of the firing, then your piece can go into the oven without being handled.

A change of colour and weight does not mean that your clay is so dry that it is ready to be fired. The speed of drying varies with the condition of the atmosphere, and a draught or a wind, if you put things in the open air in order to dry them quickly (which I would not advise) can dry things out with disconcerting speed. But however rapid and thorough the drying out may seem, it is still possible that the clay is not really dry all through; make it thoroughly warm on a radiator or in a preheating chamber, or on top of the kiln.

Despite its fragility you may find it well worth your while to work on the surface of the dry clay. There are surface qualities and exact shapes which you cannot obtain while the clay is still moist and which you may find it hard to achieve when the piece has been fired. This is the stage at which you can make an absolutely regular surface or a sharp edge, and there is in fact something particularly pleasant about such work. A knife, a hacksaw blade, needle files, graters and sand paper will all be useful now. But do remember that you are working with a very brittle material.

If you have an accident at this stage it is possible to bring the clay back to a moist condition by covering it with a damp cloth and covering that with a plastic sheet, but I have seldom found that the results are satisfactory (§39).

There are students who like to begin with, or at some stage to imitate, inorganic forms and in particular those respectable art historical objects: the cone, the sphere, the cube and the cylinder, forms to which, we are told, Nature aspires (although usually her aspirations are decidedly faint). Make them by all means, always remembering that unless they are very tiny they must be hollowed out. But if you seek, as you surely must do, for something like geometrical regularity of form, you will find at a certain stage that it is a surprisingly difficult undertaking. You flatten out one plane of your figure and make it, as you think,

[45]

quite regular; you then go on to the next face only to find that the first has somehow lost its regularity. This is particularly likely to happen if you have flattened a face by the obvious method of pressing it against a flat surface, for you will find that in flattening one face you have distorted another. In fact, whatever you do the thing will be continually losing its shape. You are inclined to give up in despair. Don't despair but do give up. Leave the object upon a tile until it is chalk-hard or almost chalk-hard, then work on it with the tools I have mentioned above and you will find that your cube is quite easily made (fig. 8); the cone, the cylinder and the sphere may be rather more difficult but they can be managed.

Fig. 8 *Testing for flatness*

In making a cube or any other form that has a plane surface, you may find it a help to prepare a flat hard surface with colouring matter, powder colour, a coloured clay or anything else that will rub off on to the surface that you want to flatten. The colour on this plane surface will show you very clearly the inequalities which you need to remove. Take the coloured surfaces away with a hacksaw blade and rub again; repeat the process until you are left with an even colour and a perfectly flat surface.

14 FIRING

In §25, I shall try to describe the manner in which you can work without a proper kiln, but here I assume either that you own or have the use of a furnace.

It is possible nowadays to purchase very small electric furnaces which you can assemble yourself. Again there are potteries which will sell furnace space, and I believe there are co-operatives whose members combine to purchase, manage and maintain a kiln.

If you have any choice in the matter get a kiln, however tiny, of your own. My slight knowledge of co-operative work makes me think that it is very difficult to run a co-operative of this kind, since all the members have different needs and these are not easily reconciled. The worker in terracotta who is not making pottery is likely to want something very different from those who are using glaze and high temperatures.

Terracotta comes into being when a piece of clay undergoes chemical change; it is still very brittle at this stage and had better be cooked until it is quite hard. But your kiln need not fire above 1000°C which, by the standards of most potters, is very low indeed. Clays vary and you will need to see what yours can do before arriving at a normal temperature for firing. I would suggest that you start by bringing your pieces to 800°C. Nearly all kilns are designed to reach much higher temperatures than this.

You may build a kiln of your own to be fired with coal, coke, or wood, or you can make a very rudimentary kiln (§25). I cannot advise on the making of large kilns, which are on the whole more suitable for the potter. I would advise you to look for a very small kiln. There are several types available which may be fired by gas, oil or electricity. To use electricity you may have to consult with your local electricity board, but I think that you will find this the easiest and the cheapest method. It is possible to arrange with the electricity board to get a cheap rate for the power that you use, and in the winter months this may mean that you will fire by night, the kiln being used, in effect, as a storage heater by day.

If you can afford it, it is well worth while buying a kiln which is furnished with a heat input regulator. This is a device for slowing down what might otherwise be too rapid a rise in temperature, a matter of great importance to the worker in terracotta. It is also very convenient to have some kind of automatic control which will switch the kiln off at a temperature decided by you. You can go to bed and leave the kiln to switch itself off.

Unless it be very tiny, a kiln is likely to have room for a number of pieces, and it may be furnished with movable shelves which are supported by columns of fireclay. When you are loading a kiln it may sometimes be possible to place a light object upon some heavier piece, but in general it is best that each model should sit upon its own shelf. Sometimes in the case of very delicate objects I have used a sagger, which is simply a box of fireclay fired as high as the kiln will go. Into this I put my piece, burying it in sand so that the heat will reach it very gradually and be well diffused around it (§26).

Your kiln is likely to have spy-holes through which you can see what is happening within. Don't look through an upper spy-hole when a lower spy-hole is open or you may get a blast of very hot air in your eye. If the spy-holes are left open, as they should be, at the beginning of a firing you may be alarmed to see smoke and/or steam pouring out of them. The smoke comes from the paper stuffing in your models, the steam from the still captive water in your clay; both should be allowed to escape through the spy-holes. The fact that they have been left open will also slow down the heating of the kiln, which is all to the good.

When smoke and steam have ceased to issue from the kiln replace the stoppers of the spy-holes and let the whole thing rise to whatever temperature you want.

This being what the potters call a 'biscuit' firing and not 'glost', you may remove the pieces as soon as they are cool enough to handle with an oven glove; but if you have the patience to wait until they can be held in the hand it will be a little safer to take them out of the kiln.

Those who supply the kiln will be able to supply information concerning the length of time needed to bring your ware to the desired temperature. To conduct the kind of operation that I have attempted to describe you almost need a pyrometer. But there are still potters who use seger cones. These pyrometric devices are not shaped like cones but rather like obelisks, which bend at a given temperature (fig. 9). They are useful if you use a very primitive method of firing, and in any kind of kiln they can show you, as the pyrometer cannot, the variations of temperature within your furnace. They are numbered and the numbers bend at a given temperature. You set them in a row opposite your spy-hole and looking through you can observe them bend one by one. When the 'cone' marked for the highest temperature is just beginning to nod you can tell how hot it is with fair exactitude.

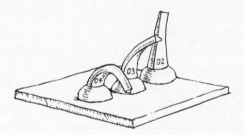

Fig. 9 *Seger cones*

15 FIRED EARTHENWARE

The opening of a kiln is always a dramatic moment. When you find your piece intact but transformed, no longer soft or brittle but hard as stone and fixed for ever, you rejoice.

But this is also the moment when you meet disaster. A thing that was too thick may have exploded, in which case there may be nothing that can be done. There are very likely heat cracks or other minor accidents which can be set right (§16), or it may be that you do not like the matt, amorphous quality of the terracotta itself, although this also can be altered (§17).

It is when you take a piece from the kiln that you become aware of the hitherto unnoticed defects, little asperities or passages of careless work. With needle files or other abrasives you can mend matters, and it may well be that you have chosen to leave the carving, fettling, smoothing process, which I mentioned in connection with chalk-hard clay, to this later stage when it is more safely undertaken. When the clay has been fired it is possible, if the piece be carefully wrapped in cloths or foam rubber, to hold it in a vice.

16 JOINING FIRED EARTHENWARE

Fired earthenware models are like bricks, they can be joined together to give you a piece of any size. If you have a small kiln and large ambitions you may well undertake large pieces of sculpture which are fired in quite small sections and then joined together. Or you may be obliged to make joints owing to breakages; or you may find, when you take your sculpture from the kiln, that you have heat cracks so large that they cannot be disregarded, or holes or other cavities.

Remember that at this stage you are no longer obliged to keep your model hollow and therefore, if it be convenient, you may if you wish fill the interior with cement (i.e. 1 part cement to 2 parts fine sand) or anything else that suits you and this may be your best method of proceeding in some cases (fig. 10).

Here are various adhesive mixtures that you can use:
Plaster of Paris (§40) or plaster mixed with grog (see below);
grog and some form of glue (one-third grog);
cement or cement and grog (one-third grog);

The purpose of the grog is to give your mend, as far as possible, the colour and quality of the model itself. It should of course be made of the same clay as that of the model.

To make grog, powder some chalk-hard clay, pass it through a fine sieve and fire it.

When you have made a joint of grog and glue you may find that

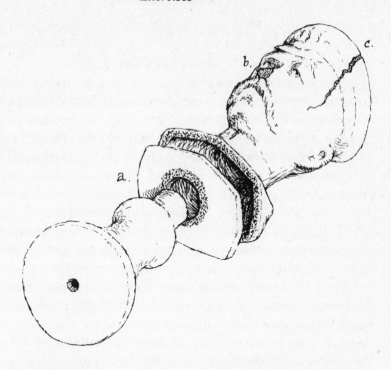

Fig. 10 *Joining and patching.* a *Attaching stand to finished piece: cement, cement &*
grog; b *Remodelling: cement & grog, plaster & grog;* c *Heat cracks: glue & grog*

it helps to powder the surface of the joint with grog.

The fired clay is porous and quickly draws the water from your cement or plaster, which makes it awkward to use plaster and may fatally weaken a cement joint. Therefore, in using these materials, first soak the parts that are to be joined and, when it is a cement join, bind the joined parts with a damp rag and, if possible, enclose the whole in a polythene bag.

If your sculpture is to stand in the open air cement will make the best bond, plaster the worst; nor should you then fill up the model with cement or plaster. If you do, the cement or plaster may become waterlogged, freeze and destroy the entire piece.

THE TREATMENT OF SURFACES

17 SURFACE QUALITY

The question of what surface quality to give your sculpture is a matter of considerable importance. Also, it is a matter concerning which there is a good deal of strong, and more or less irrational, feeling. It is held by some that the material out of which a piece of sculpture has been made should be at all costs respected. Wood should retain the quality of wood, marble of marble, bronze of bronze, and clay of clay. It is also felt, or at least it has been felt since the Renaissance, that sculpture should not be painted. There is clearly a certain charm, deriving perhaps from long habit, in the terracotta figure which remains frankly and simply of the colour that results from firing, whatever body you may use, without any kind of added pigment; but that is not a reason why the student should not be informed concerning other possibilities which were exploited by the ancients and the Chinese who used colour, and by many later workers who modified the surface quality of terracotta figures to make them more reflective.

A free-standing terracotta figure is a device for catching the light, and usually the artist has no way of telling which of the great variety of possible shapes that belong to any solid object will be used by the eventual owner of the sculpture. Other people will decide upon the colour, scale and luminosity of the environment in which his work is placed; all that a model maker can do is to offer the richest possible variety of images. To this end nothing is more important than the colour and the reflective power of his work.

Working in moist clay you will probably appreciate the extremely attractive quality of your medium. It is not glossy (remember that a high gloss tends to concentrate the light upon a few points and is therefore in some measure destructive of form); nor is it so matt as to leave you with little but a silhouette. It has about the same reflectivity as an egg shell, enough that is to give you a lively but not too violent description of surfaces. Clay that

has been allowed to dry and has then been worked may gain a little additional brilliancy and something like the polish, though never the translucence, of alabaster. But when you fire clay to the point at which chemical change occurs these agreeable surface qualities vanish. Fired clay absorbs light and tends to destroy surface qualities.

The usual problem of the terracotta worker is to restore something like the original quality of the moist clay (§21).

Or he may wish to retain the matt clay as it is when fired but needs to make it waterproof (§21).

Or again he may wish to use colour either before firing (§18) or at a later stage (§§19, 23, 24).

Or he may look for a high gloss finish (§§19, 21, 22, 23, 24), a glaze and/or a metallic finish (§§23, 24).

18 SLIP AS PAINT

Make some experiments before painting your sculpture with slip, particularly if you are using a clay different from that which forms the body of your work.

Usually it is safe to apply slip to clay which is nearly but not quite dry. A lot of slip on a very moist body can cause the body itself to become too damp and thus cause accidents. Slip can be applied to dry or even to fired clay (when it will need to be refired) and here the danger is that the slip will fail to adhere.

The Tanagra figures, so far as I can make out, were dipped in a bucket of white slip. This has the effect of an even coat of white paint; this can destroy a surface or cover up blemishes. If you do this be sure that your model is strong enough and hard enough to withstand the sudden moistening.

Slip painted onto a hardish body and fired to a low temperature gives you a sufficiently even coat of colour and may form an admirable ground on which to paint other colours. Slip can also be used if you want to make a pattern or drawing of any kind; a sharp point or a small loop can be used on the slip to make a very clear incised pattern. Working in this manner it is quite easy, if

you make a mistake, to repaint with slip and redraw.

If you are going to put glaze on your slip (§23), which for some purposes is essential, and then fire to a temperature of 900°C or more, you may find that any inequalities in your brushwork will show up. Where the slip is thin it may amalgamate with the glaze and, very nearly, disappear.

The natural colours of your clay – deep red, brown, biscuit, naples yellow and every shade of brownish red to pure white – can be obtained by finding the appropriate clay, grinding or crushing it to powder and mixing it with water. You can buy slip stains of these colours from a dealer, who can also sell you blue slip stain (there are several varieties of blue, some purplish, some greenish), and a very serviceable black stain. If you mix a little oxide of copper into your slip you can get a very beautiful bluish green, but only when there is a glaze with which the colour can amalgamate. Green, yellow and pink stains can be obtained.

19 COLOURS OTHER THAN SLIP

Almost any form of pigment will adhere to terracotta and, in addition to slip and to those colours which are used in conjunction with glaze (§23), I have tried oil colours, wax coloured crayons, ink and powder colours mixed with polyvinyl acetate, and I have used water colour (in which term I include gouache).

Polyvinyl acetate, when used with very little water, gives a glossy finish which can be attractive, but to my mind by far the most beautiful quality is that which is produced by ordinary water colour used without too much water. The colour sinks into the fired body giving a wonderfully rich matt effect which seems to enhance the modelling of the surface. Mistakes can be deleted with a sharp knife and/or a little sandpaper.

I have kept pieces, painted in this manner, indoors for ten years without any fading or other deterioration, but I find that customers like such work to be waterproofed. I have found that ordinary picture varnish will act as a waterproof, and a matt acrylic varnish keeps the original non-reflective quality of the

water colour. But once varnished a piece cannot be altered.

20 A NOTE ON SPRAYING

It is not an easy matter to cover all the surfaces of a piece of sculpture with a brush, and to do so in such a way as to leave a perfectly even coat is very hard indeed. It is very much easier to cover a surface, particularly a highly accidented surface as, for instance, one made to imitate hair or foliage, by using a spray.

A number of commercial products come in tins which can be used as sprays; it is also possible to purchase spraying apparatus. But on many occasions a fixative spray or *bayonet à fixer* can be used (fig. 11). This consists of two tubes one thinner than the other, hinged so that they can be set at right angles to each other. The thin tube is set in a vessel containing whatever it may be that you want to use as a spray. You blow through the thick tube and, after one or two bosh shots which result either from the fact that

Fig. 11 *Fixative spray*

one tube is blocked, or that the thin tube is not actually in the liquid, or because the tubes are not at the right angle, you learn to blow a fine cloud of glaze or colour on to the model. Put the object to be sprayed on a lining wheel and turn it round as you spray, remembering to blow from above and below. It is a great labour-saving device and has many uses.

You can buy a spray gun which will save your breath and is probably worth while if you are doing a lot of spraying, but this device is less versatile than the fixative spray.

21 WATERPROOFING

Terracotta is an absorbent material; on the whole the lower the temperature at which it is fired the more absorbent it will be, but different bodies react in different ways to heat. Obviously, if a piece of sculpture stands in the open air it is likely to absorb water, the water is likely to freeze and in freezing to break the pieces.

Almost any varnish or glaze will resist water, but I would suggest that in addition to these preparations, the sculptor should give his work a preliminary coat of water-glass. Chemists sell water-glass for the preservation of eggs and recommend a solution of 1 in 10, i.e. 10 per cent water-glass to 90 per cent hot water, well stirred together. Terracotta needs a stronger solution – up to 50 per cent water-glass – and even so the water-glass is likely to sink into the body so completely that more than one spraying will be needed. This slowness can have its advantages; if you spray or paint the piece several times you will in the process see the surface gradually acquire a gloss and you can leave off at the appropriate moment. In the end you will have just about the degree of reflectivity that you want.

On top of the water-glass you can add any kind of varnish. It is also safer to apply a liberal coat of boiled linseed oil if a piece is to stand in the open (§37).

22 OTHER FORMS OF VARNISH

No form of varnish should be used without preliminary experiment, and it may well be that you will want first to spray your terracotta with colour before applying varnish.

There are a great many different forms of varnish that can be used. I have had good results with various forms of picture varnish, including acrylic (which can also be manufactured as a matt water-resistant varnish). PVA medium used pure or slightly diluted makes an excellent varnish.

23 GLAZES

If you are a potter, or can command the services of one, it will no doubt occur to you that the perfect finish for any kind of terracotta is glaze. There are many different kinds of glaze and there are a great many different things that one can do to any particular glaze. If you have the time and the inclination you can make your own glaze, but if your main interest lies in the making of terracotta figures it is probable that you will want to use a glaze that is ready-made. If this be the case I would suggest that you ask for a semi-transparent glaze. It can probably be made more or less transparent by being fired at varying temperatures and one onto which you can paint oxides of various colours. It will probably come to you in the form of a powder which can be mixed with water. It would be best to ask for a glaze which fires at a comparatively low temperature, say 900–1100°C, but of course much higher temperatures are possible. Or it may be that you would find the kind of surface quality that you want by firing your piece up to a temperature at which it would vitrify (I can offer no advice here). If you work at lower temperatures and want to use glaze, remember that the usual method of glazing, that is to say dipping the piece into a vat of liquid glaze, can produce a very thick coat. This may be just what you want, but if you have been looking for very subtle modelling this is likely to disappear beneath thick glaze.

The alternative is to apply a film of glaze so fine that every last

detail will tell. To do this: make a weak solution of your glaze and spray it on (§22).

A thick glaze can be painted or sprayed with oxides, that is to say with the kind of ceramic colour which is used to decorate ware which is coated with unfired glaze. Such painting may be difficult if the surface has been very lightly sprayed. You can, however, rely upon decorations in coloured slip (§18) or in enamel colours which are painted on the fired glaze.

Gold, silver and lustre can also be painted with excellent effect on to the fired glaze (§24).

Dealers in ceramic materials offer a wide range of on-glaze colours, i.e. colours which can be mixed with fat oil and painted onto a glazed and fired surface. Staffordshire figures are usually painted in this manner, and so are many porcelain figures. The colour fires at a low temperature. It is very much out of fashion.

24 METALLIC SURFACES

One of the most beautiful terracotta figures that I have seen is the figure of a hermaphrodite. It is, if memory serves, Hellenistic and dates from about 200 BC and is in the Ashmolean. A few traces of the gold with which, presumably, it was entirely covered are still visible. I mention this to give courage to those who would like to paint their work in gold or silver or some other metal, but know also that people of really refined taste think this to be both false and vulgar.

There are a great many different preparations which give a metallic finish. If you glaze your work you may decide to use gold, silver or lustre, all of which can be obtained from ceramic merchants, can be applied with a brush and fired at a low temperature (about 700°C). The gold that you use in this process is, I believe, the genuine article; certainly it looks very fine and, as you may suppose, costs a great deal.

Far less expensive are those gold, silver and bronze water colour paints which you can get from any artist's merchant; they can be applied like water colour, to which indeed they make an

excellent foil. There are also various forms of gilt paste used by frame makers. I have never used gold leaf, but no doubt this is possible.

Here is a recipe for making an almost exact imitation of cast bronze:

When your piece is fired, spray on a mixture of Copper Oxide and Manganese Oxide (50/50), taking care to spray the piece all over; it is easy to leave a part unsprayed and it looks very odd if you do. Then, again using a spray, apply a thin film of transparent glaze. Fire to the higher temperature of your glaze.

If you like, rub on a little gold or lustre and refire.

It must be admitted that the final result does not look in the least like terracotta, but I find it very attractive.

III *Minimum equipment*

The three articles which follow are intended for beginners and those who instruct beginners. They are autobiographical and describe my own first attempts to model clay. I hope that what I say may help those who teach young children. The adult beginner may be content to know that he needs nothing, so long as he is working on small objects, but some clay, a fire capable of reaching high temperatures, a place to work in; and a piece of fine wire would help. That is unless he is going to use plaster, a considerable undertaking which is discussed below.

The beginner will not want to buy a large and expensive kiln and will probably be content to begin with small or fairly small objects: a figure less than 6in (15·2cm) high and 1½in (3·8cm) broad is the kind of thing I have in mind. Remember that limitations of size will not prevent you from doing figures as fine as the Hellenistic work of Myrina and Alexandria and that, since pieces can be joined together, the limitations imposed by the difficulty of firing large pieces need not prevent you from making things which, when assembled, are quite large.

The difficulty nowadays is to find a good open fire and coal or wood, but much of that which follows will apply also to those who can get the use of a kiln or can buy one of the very cheap small kilns that are now made. For the rest, it is child's play.

'Child's play' is no figure of speech. I began making terracotta of a very primitive kind when I was seven and my brother was nine. We dug clay from the garden, smuggled a lump into the house and modelled it on a kitchen table. We fired it by throwing pieces, often when still moist, into the nursery fire where they frequently exploded.

At some point we had been given a box of bricks; these

vanished as such things do vanish. We decided to make some more. We knew that bricks were made of clay, and that they could be modelled with the fingers; if they were allowed to dry quite a large percentage survived. These could then be used to build houses and other things. We were able to collect quite a large number of irregularly shaped but quite usable bricks using no tools save our fingers and no furnace save the open fire.

If you have the fuel and the space, it is perfectly possible to make a primitive kiln which will work well enough for biscuit firing to a comparatively low temperature:

Dig a trench about 5ft (1·525m) long, 2ft (61cm) deep, and 1ft (30·5cm) wide, lying in the direction of the prevailing wind. Supposing this to be south-west, construct near the north-eastern extremity a chamber lined with fire bricks about 2½ft (·762m) square (fig. 12). In this you place your wares, putting them

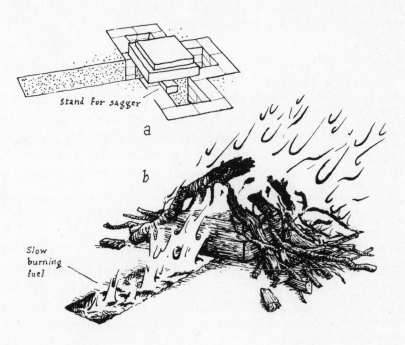

Fig. 12 *Outdoor kiln.* a *Construction;* b *Firing*

into a container (§26), and this should then be surrounded with wood or any other fuel. The whole of the south-western extremity of the kiln should also be packed with fuel, for preference one that will burn slowly.

Light the fire at the windward extremity and once it is established try to keep it from burning too fast; you want the heat to reach the chamber slowly. When the fire does reach the chamber, go on adding fuel until the centre is red hot. The longer you can make this process last the better.

26 THE CONTAINER

This was our first improvement. Thrown haphazard into the fire, bricks got lost or thrown away by ignorant grown-ups. The container gave us greater productivity and we soon noticed that if our bricks were packed in sand so that there was sand below them, above them and all around them, the number of failures diminished. Our first container was a tin, in fact a treacle tin packed with sand and bricks, the lid of which was pierced and fastened down when in use.

A more sophisticated form of container was the 'sagger' and this is something which you may use with large kilns because it reduces the risk that your ware or someone else's ware may be damaged by an explosion, an important consideration if you are sharing a kiln. Also, it may be useful for containing particularly delicate pieces, for an object packed in sand inside a sagger is safer than it would be when fired in any other way.

To make a sagger (fig. 13): wedge up a mass of soft clay with sand until the body has a gritty quality. Then roll the clay into long rolls; these you curl round and round until they form the shape that you want for the base of your sagger (a roughly oblong shape is best). As you set your rolls side by side to reach the required shape, join them together with slip and a tool, working the whole into an even surface in which no joints are visible. Having made the base, form your coils into a wall, using the same method to amalgamate the coils. Go on until you have reached a

Fig. 13 a *Primitive sagger*; b *Building a clay sagger*; c *Filled sagger in section*

suitable height, then, very carefully finish off with an even rim. The lid should be furnished with a vent hole so that hot air and steam may escape (§11).

Let the sagger dry until it is very hard, then fire it in the fiercest and largest fire that you can make or use.

Remember in making the sagger that there should be room not only for the things that you want to put in it but for the sand in which it is packed. One great advantage of the container is that it allows you, by packing an object, to bring the heat to it gradually and in a diffused manner.

27 MAKING BRICKS

Continuing this autobiographical survey, I must adventure into a discussion of what can be done with casts. So far I have said nothing about castmaking, for reasons which will appear (§28), and the actual technique of casting will be discussed later (§§29–34).

Obviously it is best to have bricks which are all exactly and neatly made to a pattern. To make them thus without using a cast

is not easy. One rolls out a sheet, of as even a thickness as possible, using clay which is just not too stiff to be workable, measures it out carefully and cuts it with a sharp knife, keeping the blade upright and using a metal ruler. For all one's care, the bricks are not identical in appearance. But if one can make a really good brick and take a mould of it, then by a process hereafter described, one can take prints of one's original and the bricks are identical.

Here let me record the very strong recollection of pure delight with which I made this discovery and the even greater excitement which resulted from a further very simple application of the method. For by printing off five bricks, setting them side by side and making a mould from them, I found that by two very simple operations I could bring into existence five smart perfectly formed bricks about the shape and size of dominoes. It took perhaps a minute. After an hour of happy work there were about 300 bricks; by the end of the morning I had enough to build a city. Nor was this all; a few of the bricks were failures; they became half-bricks and, as such, extremely useful in building operations, for with half-bricks you can build a regular calculable wall. This in turn breeds a whole family of regular forms, pilasters, columns, arches, lintels, architraves, sections of tiled roofing, domes, cupolas, pavements, all of them based upon a modular which derives from the dimensions of one's original brick (§30).

In the earlier phase, when our bricks were rude and crude, they still served very well, particularly in a sandpit, to form rough and ready ravelins, bastions, tenailles, such as would have pleased Corporal Trim, and which could be battered in true military style from judiciously planned parallels.

I fear that all our cities were devoted to destruction; but with accurate multiple casting the joys of destruction were almost equalled by those of creation. Who can resist the pleasure of designing avenues, colonnades, piazzas, theatres, railway stations, and viaducts, the winding course of a silver-paper river adorned by fine bridges and baroque sculpture, the public

gardens complete with monuments and plantations of parsley or asparagus, all of which is made possible through the use of bricks of a regular and usable size?

And all this without the use of a kiln and with minimal equipment.

IV *Terracotta involving the use of plaster*

Long before the invention of movable type, people were making accurate prints of sculpture by means of moulds. The moulds were usually made out of clay. Clay still has its uses as a moulding material, ones to which I shall advert (§34). But nowadays plaster of Paris is generally used and is indeed a most convenient and versatile substance. For your purposes fine plaster, sometimes refered to as 'Fine Italian Plaster' or 'Dental Plaster' will be best; for some large-scale projects a cheaper substance may be used (see below). A fine plaster, if properly handled, will give you a wonderfully exact impression.

Plaster, it must be said, is a dreadfully messy substance; it can so easily get spilled either in a liquid or a powdered form; it can quite easily get into your clay and it is dangerous to re-use clay which has been used in casting, unless it has been carefully cleaned. Plaster gets carried from the workshop into the home where it is particularly unwelcome and it frequently comes in a messy form – a mixture of clay and plaster which is fatal to carpets. Altogether it is a good plan to make sure that you want to work in terracotta and to take precautions when leaving the workshop before exposing the rest of the household to plaster. It is much more labour-creating than clay.

Plaster can be purchased in small quantities from a chemist. If you are doing a lot of work it will pay you to buy large quantities; so long as it is kept in an airtight container, it will not deteriorate for a very long time. For very large jobs you may use a coarser plaster, which a builder's merchant will probably be able to supply. It does not give you so fine a print as good dental plaster, but that you may use as a facer on the actual surface of the mould, with coarse plaster to back it up.

MOULDS

29 MAKING A PLASTER MOULD

Start with a simple shape, say a tile. Make a tile of clay or find a tile of which you want to make copies. You had better begin with something small: 4½ x 4½in (11·4 x 11·4cm) would be a convenient size. Find an absolutely flat surface and on that surface lay a sheet of smooth damp paper and place your tile on it (fig. 14a). If there is any space between the tile and the paper on which it lies, or if the edges of the tile lean inwards so that the top is a little larger than the bottom, fill the space with soft clay so that liquid plaster cannot flow beneath the tile, and so that you are not left with an object which is gripped by the hardened plaster in such a way that you cannot withdraw it from the cast.

Then build a wall of clay (some people also use cardboard or linoleum in order to make a wall); this wall should surround your tile completely (fig. 14b, c). There will be a stage in which the wall surrounding your tile has to contain a pool of liquid plaster and you must make sure that no liquid escapes. Before you begin to mix your plaster make sure of two things: if you are working from a solid object, say an earthenware tile (and I would advise you to begin by casting on to clay for it is easier to remove), see that the tile is well covered with a resist: grease or soap, clay or oil.

Provide yourself with two handfuls of moist clay and have them within easy reach.

Then try to calculate, though it is not easy, the volume of plaster which will form your mould. Take from your plaster bin about enough dry plaster to fill half the mould and, using a plastic bowl for preference, pour into it a quantity of clean water equal to the quantity of plaster. It is best to have rather more plaster ready to hand than you are likely to need.

Sift the plaster through a coarse sieve into the water (fig. 14d); it is important not to throw it in in large heaps, as the powder will fall through the water and collect with air at the bottom of the bowl. Continue with careful haste to sift in plaster until it lies in an

even mass just below the surface or until a little island of plaster begins to appear above the water's surface. Rap the side of the bowl smartly, but not so hard as to break the surface of the water; this may release air bubbles that have gathered in the plaster. Too smart a blow may actually cause bubbles.

Slowly pour the liquid plaster around the tile, trying to cover the whole area with liquid and trying not to create air bubbles (fig. 14e).

If, at this stage, a stream of liquid plaster bursts through your wall, and this can happen, plug the leak with your lump of soft clay.

Different plasters dry at different speeds; very likely you will be surprised by the rate at which the liquid becomes a solid. At the stage when it is firm enough not to collapse, remove the clay wall and you will find that the upper edge of your mould is irregular in shape (fig. 14f). You can smooth out the irregularities with your hand. A smooth cast does not break at the edges, thereby producing little grains of plaster which tend to get into your clay.

The clay which you have used in making the walls of the mould and soft clay which has been used, and in fact all the clay which has been in contact with the wet plaster, is bound to be 'dirty' and should go in the waste bin.

When the plaster is quite hard (it takes about a quarter of an hour to harden) it is safe to remove the tile or whatever it may be from the mould (fig. 14g, h). Obviously this will be easier if you have moulded on clay which, if need be, can be removed piecemeal. But so long as you have been careful to ensure that there is no re-entrant form to hold the piece – that is to say no plaster that comes round and grips the tile so that you cannot pull the mould away – and that there is no surface to which the plaster can adhere, you should have no difficulty.

30 SPRIG MOULDING

If we continue to examine the possibilities of the tile we shall find that, once a mould has been made, a very simple casting process

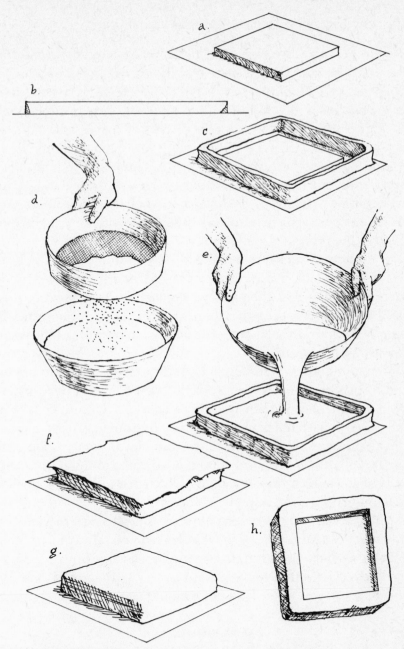

Fig 14. *Making a tile cast.* a *Tile for casting;* b *Section: patched edges;* c *Clay walls;* d *Mixing plaster;* e *Applying plaster;* f *Untrimmed mould;* g *Trimmed mould;* h *Finished mould*

[69]

can be employed. It is in fact the method which I used as a child in making bricks and is the simplest of all casting operations.

To cast a tile (fig. 15): take a slice of clay of roughly the same size as the tile, press this clay into the empty mould, being careful that the clay is well driven home at the corners of the tile, slap it down upon a rather larger piece of clay, lift the mould, and there imprinted upon the surface of the clay is a replica of your tile. The replica projects from the main body of the clay so cut it off with a piece of fine wire. It may be necessary, when the clay is harder, to trim the edges, or even to smooth the surface with sandpaper; but even so the process is wonderfully simple.

This method can be used with any slender form such as a tile, a jewel or the kind of raised ornament that you may wish to print in large quantities and then apply to a surface. Ornament of this kind is said to be 'sprigged' when it is on a plate or other ware. It simply means raised ornament applied to the surface of the ware while it is drying out.

In making moulds for 'sprigged' decorations you may prefer not to use the conventional method, which would be to make your ornaments and then apply liquid plaster. Instead, by taking any piece of hard flat plaster, you can carve out your decoration.

The process of tile-making is fast and may become furious, so much so that you break the mould in slapping it down upon the clay bed. For this reason moulds which are to be used in this fashion may, wisely, be reinforced (§35).

Your tile may carry a raised pattern or indeed it may be a kind of bas-relief. There is no end to what you can do, always provided that the mould will withdraw, leaving the clay undisturbed. But it is almost certain that you will want to cast 'in the round' and for this purpose you will want a piece mould (§31).

31 PIECE MOULDING

To make a mould from a rounded object you will need at least two pieces to your mould; for your complex shapes you may need a great number of interlocking pieces which will pull away clean

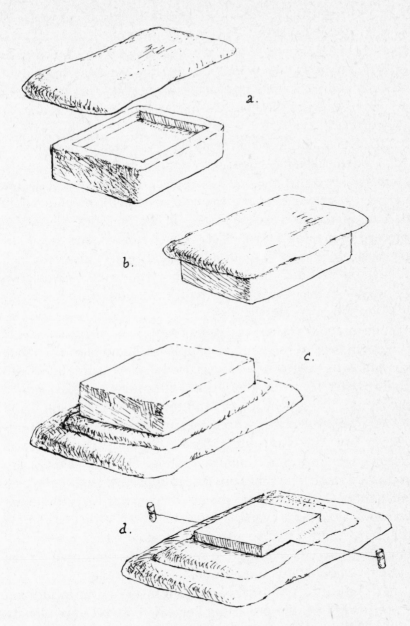

Fig. 15 *Casting a clay tile.* a *Clay and mould;* b *Clay in mould;* c *Mould upturned onto clay;* d *Cutting away tile*

from the many facets with which you are dealing. Moulds of such complexity are not needed by most workers in terracotta; all that they are likely to need is a fairly simple shape which can then be modified to taste. I say a little, but only a little, about more exact and demanding operations at a later stage (§33). But, for reasons which will appear, simple two- or three-piece moulds may be very useful.

Take then a simple shape, an apple. If you look at an apple you will observe that it has a dent at one end where the stalk grows. If, therefore, you are making a two-piece mould of it, the join between your two 'caps', i.e. the two halves of the mould, should be horizontal, otherwise the pieces will not come away clean. You proceed by making a 'wall' of clay which runs around the apple; the 'wall' should be smooth and should project about an inch from the surface of the apple. At this point you may construct two keyways – hemispheres of clay which will project from the clay wall, one on each side (fig. 16a).

Then mix your plaster. You cannot simply pour it on or it would run down the side, so you must apply the liquid plaster in small quantities (fig. 16b). Professionals use a shallow saucer filled with liquid plaster; from this they jerk out little dollops of plaster on to the mould, using their fingers and then blowing the still liquid plaster over the surface so that it goes into every cranny and forms an even face. This is not quite as hard as it sounds. The plaster will collect so that it forms a uniform coating. This will begin to dry and as it does so it becomes possible to apply a second coat which will adhere to the first, and then perhaps a third. Soon enough you will have a fairly even cap of plaster over the top of the apple (fig. 16c). Allow it to dry, turn it upside down, then remove the clay. Probably you will need to trim and tidy the surface of the plaster; it should be as smooth and neat as possible.

At this point you may make another form of keyway in addition to, or instead of, the projecting keyway that you have already made. This you do by cutting a notch or joggle in the surface of the plaster. You cut it, of course, in such a way, that the cap can easily

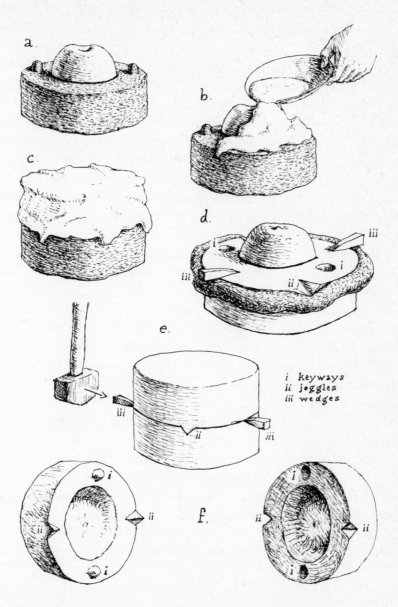

Fig. 16 *Making a two-piece mould.* a *Apple in clay;* b *Applying plaster;* c *Untrimmed half-mould;* d *Half-mould upturned with clay rim;* e *Completed two-piece mould;* f *Mould emptied*

be withdrawn (fig. 16d). This makes a nice neat shape, but if there have been any bubbles below the surface of the clay they will have to be patched.

You have turned your apple upside down so that the plaster cap is below; place it so that the plaster surface is horizontal (fig. 16d). Apply a good coat of whatever resist you may use so that the raw plaster is entirely protected. The resist is there to prevent the new cap that you are making on top of the old one from getting stuck; new plaster will stick to old plaster unless resisted (clay, oil, soap, anything waterproof will make a good resist). For the same purpose a band of clay run around the rim of the old cap will catch any drops of plaster that may fall while you are making the new cap.

Mix some plaster again and repeat the process as before. Wait until the upper cap is quite hard before separating the top from the bottom (fig. 16e, f).

If you are dealing not with an apple but with a football or have any doubt about your ability to separate the two halves of your mould when they are dry, you may introduce wedges, made of wood. These are set flat upon the plaster surface before the second cap is made (fig. 16d, e). They should be well greased or soaped. When the caps are hard you tap the wedges in with a mallet and, if you are casting from a clay model, pour water along the hairline crack when it appears.

Some moulds, when you open them, will retain a good deal of clay, particularly on rough surfaces. This must be removed. Sometimes you can bring out fragments of clay by pressing them with a larger piece, sometimes you will need a tool; if you value the surface of your cast, use a wooden tool. Sometimes water, a sponge and an old toothbrush may be needed.

CASTING

Apart from sprigging, which is practicable only with a limited class of object (§30), there are two methods of making use of the plaster cast. Your choice of methods will be determined by the kind of work that you want to do and will also affect your methods of mould-making.

If you want an exact replica of an object, and if you want to be able to reproduce it many times, then you will cast with slip.

If you want something that will give you the general proportions of an object, leaving the treatment to a later stage and making it unnecessary to excavate then, although you may use slip, you will find it more convenient to press your clay.

To make a slip cast of a complex form with many re-entrant surfaces is a very difficult task and even a simple shape calls for far more care and exactitude in the mould-making than does a press mould. Your caps must fit so snugly that they will retain a liquid, and the slightest miscalculation such as will make the dried clay hard to withdraw defeats the whole object of the exercise.

I have seldom used this method and therefore write without great knowledge. Readers who want more detailed instructions will find them in *Making Pottery Figures* by Marjorie Drawbell.

The principle of the slip cast is this: when you pour liquid clay into a plaster vessel, the clay at once dries out against the surface of the plaster, thus forming an exact copy of the shape that it occupies. Then it contracts. When the caps are removed the artificer has nothing to do except to fettle away those 'feathers' of clay which will project even into the most exactly calculated pieces.

Begin with a very simple shape. The caps must be so disposed that there is no re-entrant convexity or concavity. If there are many caps the whole must be contained within an outer shield of

plaster which will hold all in place. The plaster, whether it be a shield or not, must fit exactly and must be furnished with a deep groove which will run around the entire mould. This will contain a wire or cord which must be tightened to draw the parts together as firmly as possible. When in doubt make arrangements for a second bond around the cast.

The mould must be made with an opening large enough to allow a stream of clay to be poured in and for the air to escape. You attempt to rid the slip of bubbles, repeatedly striking the vessel which holds it, pouring in the slip as smoothly as possible. After a few minutes the slip is poured out and that which adheres to the cast allowed to dry a little; then you fill the cast again. Repeat the process until you think that the coating of slip is thick enough. Then let the cast stand until the clay is cheese-hard. Remove the caps deliberately; fettle, and, if necessary, mend with soft clay and slip.

34 THE PRESS MOULD

If you have a sufficiently simple shape, as for instance a bowl or the mask of a face, you can proceed exactly as the workers of the Hellenistic age proceeded. They had a mould which covered the front of their figures and it differed from yours only in being made of fired clay. They rolled out a thin sheet of clay and pressed it into the mould; then they painted the clay with slip and pressed in a second sheet; a third might or might not be necessary. It is sufficient to cover the mould to a depth of about ½in (13mm). Take care to press home the convex shapes and, where there is a sharp concavity (which on the mould shows as a convex lump) you press on a little extra clay, for here the sheet may well prove too thin. Then if you were an ancient Greek, you would stuff the remaining cavity with hay or straw and cover the back, sometimes in quite a careless fashion, with a sheet of clay.

When the mould is thus filled, you leave the clay to dry a little; in drying it shrinks and releases itself. Don't let it dry too far, for then if you want to make changes or to repair surfaces which have

Fig. 17 *Press mould with stick for extraction*

been damaged as they leave the mould, it may be hard to work. A stick thrust into the stuffing and projecting outside the mould may help you to lift the object out (fig. 17), or you may gently work the clay loose from its mould with the blade of a palette knife and work it away from the cast. Since you are not attempting to make a replica you will not mind doing a little repair work.

It has been said of the Tanagra figures that there are amongst them many sisters but few twins. In other words, the Greeks adjusted their statuettes after removing them from the moulds, altering the poise of a head or the positioning of an arm, slight changes which produce a radical effect. It is not difficult.

But probably you will want free-standing objects and need to make a more ambitious type of mould than that which was common amongst the ancients. In fact you will need a two-piece mould (§31).

Consider how you would press-mould the cast of an apple which I have used as an illustration above. Proceed as with a one-piece mould but when you have put in your shell of clay, trim it off so that on each cap the clay projects very slightly beyond the plaster. Score this projection with a pointed tool and treat the scored surface with slip almost of the consistency of butter, repeat the process, press the caps or shells together, allow to dry and remove.

A refinement on this method recommended by some authorities is to cut a groove in the flat surfaces of the plaster; thus, when the two clay shells meet, the clay is, as it were, bitten off, and you avoid the danger of being left with so thick a mass of waste clay lying between the opposing caps that the size of the moulded object is falsified. I myself have found that with a little more care this is unnecessary, but the two halves do need to be worked together with a tool so that the clay amalgamates. A little surface treatment is needed if you want to hide the joint, but, using this method, I reckon that further treatment will be necessary anyway. Another refinement is to allow, in making the mould, for a shaft, preferably of wood, which will enter the mould and lie at the centre of the stuffing (see above).

The advantage of this method is that it avoids the business of excavating the model. You have it hollow and stuffed from the beginning (but it has to be remembered that you also have it – if stuffed – in a state which makes it awkward to effect a radical change in the pose). This is a point of some importance if you use moulded figures in order to discover groupings. The kind of process that I have in mind may be described thus:

Using a two-piece mould you make, say, four identical figures (it is quickly done if you are not concerned with detail). These figures can be disposed within an environment of your choice. They can easily be supported in a temporary fashion in whatever poses you like; you can add or subtract, arrange and rearrange your figures and in so doing discover compositional and/or dramatic groupings in a way impossible in any other medium. Of course your moulded figures are but a rough and ready indication of what you will finally seek. But they provide an extraordinarily rich and imaginatively exciting beginning.

For large-scale work the press mould is, almost, a necessity but this will be discussed later (§37).

The student will soon discover that very small objects are very difficult to make. There is a point where your fingers are too large for the job and even with specially fine tools the difficulties are

immense; they can in great part be overcome by the use of the press mould or sprig mould.

To make a reduced figure: model your figure in clay, making it as small as possible and as apt as possible for being cast in a mould. Let it dry; in so doing it will shrink. When it is really hard, treat it with a resist; lubricating oil will answer very well. Then, taking a thin sheet of soft clay, press it down on to the dry model and build with a further layer of clay so as to make a mould or matrix. Gently remove the matrix and allow it to dry (this too will shrink), treat it with resist and fill it with soft clay using the same method. Repeat the process until the figure is as small as you want it to be.

The use of a clay mould hastens the process of reduction but, if the piece be of an awkward shape, your clay may crack and you will have to use plaster.

I have been told that the Renaissance medallists used this process.

OTHER USES OF PLASTER

35 GENERAL REMARKS

Plaster can be used for sticking things together, and it can be used for taking the water out of clay. If you want a very large mould, or a mould which is going to receive rough usage or any kind of firm structure, a plaster joint will be easy to make. For this purpose you will need two other materials: size and scrim.

Size (not cold water size) is sold in granulated form, can be bought in packets; mix it with warm water and add a little of the sized water to the plaster mix. It then acts as a retarding agent so that you have all the time you need in which to finish your job. A solution containing uric acid and ammonia will also serve as a retarding agent. I have used it as an emergency and found it worked very well. Size also serves to strengthen a bond, but it makes the plaster a little less porous.

Scrim, which you can buy in rolls from a builder's merchant, is of two kinds: hessian scrim, which is coarse and very good for strengthening moulds, and cotton scrim, which is finer and handy if you want a more precise finish.

A piece of wood or metal set against the back of a mould and fastened with scrim and plaster will add strength. Scrim soaked in plaster and wound around a joint is handy for a great many purposes.

36 THE PLASTER BED

This is invaluable in drying out clay (fig. 18).

A wooden surface – a table or half a table will serve very well – should be prepared for the plaster by being covered with wire netting, which should be nailed down. Build a wall of even height around the area that you have prepared so that it will contain a shallow lake of liquid plaster. Pour in the plaster (you needn't worry about air bubbles) and cover the wire, then lay on some sheets of scrim so that the whole area is covered. Finish off with liquid plaster.

You may find that the walls had best remain. It is wise to finish them off with cotton scrim and plaster to make a neat edge. You want to avoid little grains of plaster breaking off the rim and getting into your clay.

I have a table, one half of which is covered with slate, the other with plaster. If I have very loose (soft) clay to wedge I use the plaster, and the clay hardens rapidly as it is wedged. If I have tight clay I use the slate. Whenever I want to accelerate the drying process the plaster bed is useful.

If you have a bin of clay which has been passed through a sieve and is almost liquid (§7), you can spread out the slushy clay upon the plaster bed and within 48 hours it will be dry enough to be rolled off the bed and wedged up.

Fig. 18 *Making a plaster-bed.* a *Foundation;* b *Walls;* c *Plaster;* d *Scrim;*
e *Finish*

Do not attempt to make a large object, and by this I mean a life-sized bust or anything bigger, until you have had a good deal of experience with your clay. The great mass of clay, great by comparison with the kind of thing that we have been considering, makes difficulties. It distorts by reason of its own weight and is hard to fire; also, unless you have a very large kiln, you will have to divide your piece into sections and this can be a difficult business.

If you look at the backside of a large-scale piece of terracotta, you will probably be able to see how the hollow shell of the fired clay has been fortified by interior walls, usually lateral walls, but sometimes upright supports. The walls may also have been made to accommodate a central support which would have been of use when the clay was moist.

I strongly advise you to make a modello, that is, a scale model – say one-third of the eventual size. In doing this, make the divisions which will be necessary when the piece is life-size; and also make the internal supports so that you will not find that your divisions conflict with your interior walls.

You can work by excavation, or by making a big press mould, or by coiling. If you use a press mould, look for the general proportions and don't worry about details, which will only impede you when you want to withdraw the clay. Here, more than ever, the press mould is but the starting point for your operations.

It may be necessary to have an upright support and perhaps some lateral supports. In this case, you should look for a steel rod and a set of pipes of varying diameters which can be fitted into each other like the parts of a telescope (fig. 19). Cut them to appropriate lengths with a hacksaw so that each section of your 'telescope' corresponds to the cuts that you are planning to make. Thus, when the sections are dismantled, each section can be withdrawn, together with its own lateral supports. The laterals can be fastened on with scrim and plaster.

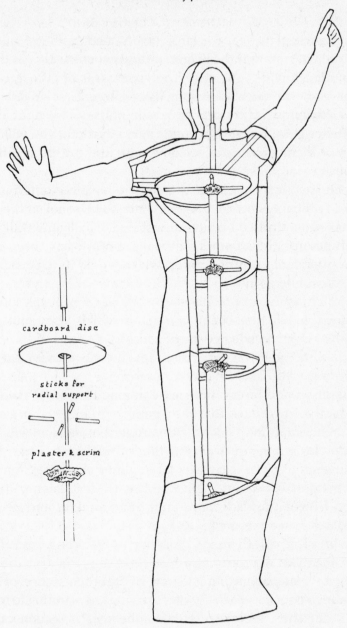

cardboard disc

sticks for
radial support

plaster & scrim

Fig. 19 *Armature for a large figure*

[83]

If you can manage without any armature and hold the whole thing up with stuffing, it will help. In stuffing it will also be convenient if you bear the eventual position of the cuts in mind, and put in a 'floor' of paper or cardboard at the point where one section has to be taken away from its neighbour.

You may build a central core of wood, polystyrene or any other light material, but in this case it is again essential to remember that the core must be made to come apart at the point where the sections are cut apart. Also you must dispose plenty of stuffing between the exterior wall and the core, for although you will separate the pieces before they are chalk-hard, some contraction will have taken place and there will be a split where the clay presses against a solid object.

There are two ways of cutting the clay so as to form sections small enough to go into your kiln. In both a first objective must be to make a clean horizontal division of the clay which will serve as a foot on which the section can stand while it is getting dry enough to fire, and which will not get chipped or bent.

The visible cut: if you have an unbroken surface, as for instance a nude body, you have no choice but to make a visible joint. This is straightforward but not very easy: it requires a firm hand and considerable judgement to make a perfectly horizontal cut. Mark out a horizontal line which will encircle the entire piece. Wait until the clay is so far dried up that there is no danger of the pieces rejoining after you have cut them. Use a long sharp knife (a wire never seems to cut straight) and take care, while following the line exactly, to keep the blade of the knife horizontal. When the piece is fired, rejoin with cement (§16; §39).

The invisible cut: there are broken surfaces which lend themselves to a discreet process in which no joint is visible: a collar, a necklace, a belt or some other feature of the model may provide a 'natural break'.

Consider the example offered in the figures illustrated. A peplum falling clear of the lower part of the body offers a fair opportunity for an invisible junction. At first sight, and in view of

what I have just said, the uneven line of the peplum makes too fragile and highly accidented a margin to make a good flat join. And indeed, if the line were sufficiently uneven, it would hardly be possible to practise an invisible cut. In this case, however, it is possible.

In fig. 20a the line 'x', which just clears the line of the edge of the peplum, which I will call 'y', will be the eventual line of the cut. Running parallel to 'x' and about 1½in (3·8cm) above it, we draw another line which we will call 'z'.

Remove the clay lying between x and z; cut right down to the stuffing, making the cut as horizontal as possible. Thus you have an empty space and, below it, the lower part of the peplum (that is to say the area between x and y). This must be sacrificed; you cut the peplum away so as to make an even surface running up from the bottom line of the peplum (y) and then turning sharply at right angles so as to leave a horizontal shelf along the line x (fig. 20c, d, e). You must model these surfaces with some care because you will want to remove the top part as though it were a lid.

This excavation should not be extended for more than a quarter of the perimeter of the model, otherwise there might be a collapse.

Cover the areas of clay which have been exposed by your excavation with a thick layer of paper (fig. 20f). Then fill in the x-z space with clay and remodel the folds of the peplum which you have had to remove. Leave a space unfilled at the extremity of your excavation; this will enable you to keep the surface smooth and continuous as you work your way round the piece. At the end you should have a horizontal cut at x buried behind about an inch of clay (fig. 20e, f).

When the clay is still soft enough to be repaired but firm enough to be set down on a foam rubber mat without distortion, lift off the upper section. The lower section now has a flat rim which can be safely put down on foam rubber, if you have planned matters well enough. The upper section should also be furnished with this kind of flat rim, but if this has not been

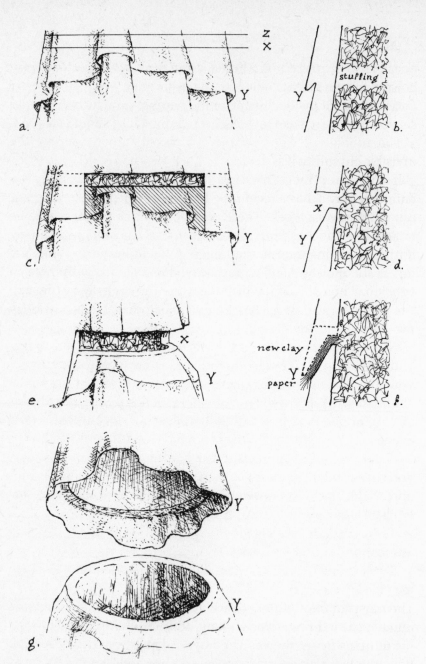

Fig. 20 Concealed joints. a Marking cuts on figure; b Enlarged section of
above; c Clay to be cut away; d Section after cut; e Profile showing modelling of
slope; f Remodelling of peplum; g Fitting of completed upper and lower parts

possible to manage you should arrange in advance for a clay bolster, a large sausage-shaped ring of soft clay wrapped in paper and made to fit inside the line of the peplum on which the upper section can sit. It is not an ideal arrangement but should serve.

The visible cut is rather more difficult than it sounds, the invisible cut rather less.

If your sculpture is to stand out of doors, there is always a danger it may act as a receptacle for water, which, becoming ice, can destroy your work. There are two kinds of precaution to be taken. On the sculpture itself, you may have rain-collecting forms, as for instance in the hollow folds of drapery. While the clay is still moist you may practise what is called a 'weep hole', a very small hole through which the water can drain away (fig. 22). See to it that the hole itself is well-oiled before it stands outside in the cold.

When the sculpture has been cemented together (never entirely fill any form with cement), and when it has been erected, you should treat it with water-glass, and in addition put on an abundance of oil or some other waterproofing agent. But there is still a danger that moisture will collect inside and this could eventually form a pool which would have very destructive effects in a hard winter. Therefore furnish your pedestal or whatever your piece stands on with a drain. It can be quite inconspicuous and can be blocked with steel wool to exclude flora and fauna, but will still allow water to escape (fig. 21).

ACCIDENTS

38 PRECAUTIONS

The most common causes of accidents are careless handling, too much haste in firing, overworking, visitors, children and frost.

Put up as many shelves as possible. The more shelf space you have the less risk of accidents caused by carelessness. As far as possible pieces should be kept on tiles, furnace shelves (which are large fire-brick tiles) or any other solid support; if you follow this

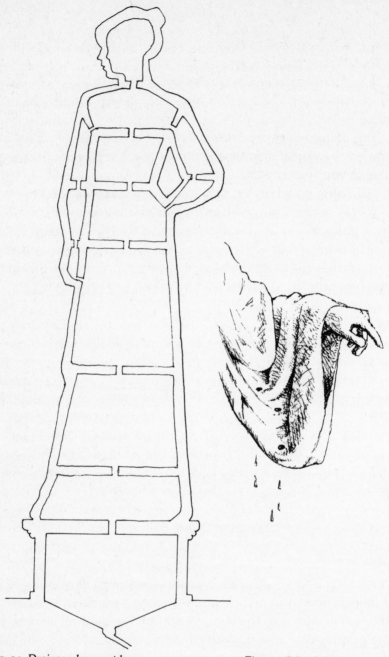

Fig. 21 *Drainage: large outdoor*
figure shown in section

Fig. 22 *'Weephole'*

practice and can get into the habit of moving the pieces by moving the shelves, it will be a great help.

Always raise the temperature slowly when firing. If you have a piece which might explode in the kiln, screen it from the other pieces.

The danger of overworking is this: if your piece is hollow and you work away at a surface you may go right through, leaving a hole in your piece (§39).

I can offer no advice on how to exclude visitors or children.

A very severe frost, such as may strike an outbuilding in which your pottery is housed, can be the most disastrous thing. A very small burner, oil or electric, such as is used in garages, will serve to avert this. If this is not possible, move all unfired ware from the pottery and place it indoors or you may lose everything.

39 MENDING

Most accidents to moist clay are easily repaired; the dangerous stage is when the clay is chalk-hard and very brittle.

It is possible with damp cloths to bring a chalk-hard clay back to a moist condition and repair it. I have rarely found this method satisfactory, but other people tell me that it works very well. In the case of a clean break, for instance a nose or a foot that has snapped off, I have adopted the following method with success. Before the object is fired, I bore a small hole on each broken surface so that the holes will correspond when the piece is rejoined (fig. 23); then fire the two parts together. When fired, I put a member of stiff wire into one hole so that it will reunite the pieces, fill the cavities with glue, and press the two parts together to make a firm joint.

A cavity in the wall of a sculpture can be very hard to deal with if there is no way of getting into the piece; your mending material simply falls through the hole. The following method is tricky but can be quite effective. Take two pieces of fairly stiff wire and bend them together so as to form a cross (fig. 24). Bend the arms of the cross so that it stands away from whatever surface you may put it

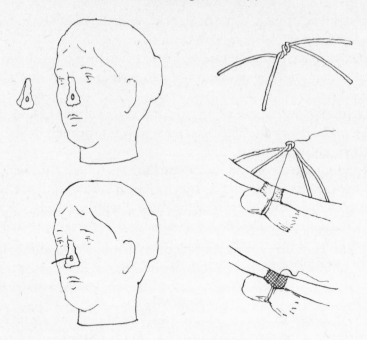

Fig. 23 *Mending breaks* Fig. 24 *'Spider'*

upon, so that in fact it looks like a four-legged spider. At the joint of the cross, attach a short length of thread and at its other end fasten a lump of cotton wool or scrim small enough to be pressed through the hole that you have made. Press it through. It will expand. You draw it back so that it blocks the hole. You fasten it against the 'four-legged spider' and if necessary the wire legs of this device can be flexed to apply greater pressure. Then with a mixture of glue and grog you can fill the hole, let it dry, cut or burn away the thread and polish or paint the surface.

All fired terracotta can be mended with a mixture of grog and glue, including the heat cracks which you will sometimes discover after firing. The surface of the join should be powdered with pure grog.

40 REPAIRS WITH PLASTER OR CEMENT

A very large break in a hollowed-out piece may have to be mended in such a way that the shape has to be remodelled, which would hardly be possible using grog and glue.

This can be done by filling the piece with plaster or cement and reworking the surface. A plaster surface when painted may be made quite indistinguishable from the rest of the body. Plaster should never be used for a piece which will stand in the open.

Whichever material you are using, begin by soaking the broken piece in water for at least ten minutes. This retards the drying of the mend, which is desirable when you use plaster and essential when you use cement.

Make a clay support to your piece so that it is held at the right angle and fill the whole with plaster or cement. If you use plaster you can go on working on the piece, clearing up the messes that are almost bound to occur and trimming the whole, until it is quite dry. If you use cement you must, when you have filled the cavity to your satisfaction, wrap the whole thing in a damp cloth and then enclose it in plastic. The longer you can delay the drying of it the better.

v Cautionary tales

There was once a young potter who dug clay from the bottom of
his garden. It was a beautiful blue clay which, when taken to low
temperatures, turned a delightful salmon pink. But even at low
temperatures it tended to crack, indeed it cracked abominably
when it was chalk-hard. This, the young potter said to himself, is
the result of some impurity in the clay. He therefore washed it
and passed it through a potter's lawn; it cracked worse than ever.
He made it even more pure; it became still worse. It took him
some time to realise that the clay needed to be not pure but
impure; by adding fine sand he cured it.

This was not the end of his troubles. He had no kiln, he longed
for a kiln and when he finally got a kiln he was so excited that he
acted recklessly. Having no pyrometer he used seger cones to
measure the temperature. Unfortunately he placed them so ill
that they collapsed when he shut the door of the kiln. Impatient
and undeterred he went on firing, judging the temperature by
eye. After a time it got rather hot. The next morning it was still
very hot.

Now, that kiln was packed to the roof with pottery of all kinds
and our young potter could not wait to see what had become of it.
He decided that it had cooled down enough and flung open the
doors. A blast of hot air came out and took off his eyebrows. This
worried him a bit; what worried him more was that the kiln was
empty.

When eventually he was able to look carefully, he found that all
his wares had melted and fallen to the floor of the kiln and lay
there like a nasty pudding of dirty glass.

The clay he was using was of a kind that would turn into what is
called triple silicate of iron; it liquefies at a comparatively low
temperature.

Morals:

1 Remember that purity does not always produce strength.
2 Take a sample of your clay to a high temperature before risking anything of value in the furnace.
3 Don't be impatient.

42 CAUTIONARY TALE B

I used to know an enthusiastic teacher in an enterprising school. The school purchased a wheel, a kiln, bins for clay, plaster beds and heaven knows what else.

Then a bulldozer clearing the ground for a new gymnasium uncovered a very attractive deposit of clay. The teacher was delighted. Now the school would have its own body, the pupils would learn the essentials, he called them the 'basics' of the potter's art; they would dig, weather and wash their own body. What could be more educational? That summer term they dug with great enthusiasm and began to prepare the clay; but the process took time and no actual pots had been made when term ended.

In the autumn term the main enthusiasts had left, the survivors were not so keen, the work languished. The preparatory stages seemed tedious and the pupils wanted the school to buy some clay. The teacher would not hear of anything so poor-spirited; it would be a shameful thing not to use their own body. But by Christmas the children seemed to have lost interest, a number of tiresome accidents supervened and still no actual pots had been thrown.

In the spring term no one opted to do pottery. The wheel stood clean (a rare thing in schools), but it was clean because it was unused. The clay was still not quite ready for use; I do not know whether it was ever used.

Moral: It is better to arrive than to go on travelling hopefully.

CAUTIONARY TALE C

I used to teach a class of unruly but delightful girls in a rather grand, or at least a rather expensive, school. I did not teach much but I learnt a good deal. In the school buildings there was a room which had once been a kitchen and this I converted into a rudimentary pottery.

The girls got thoroughly out of hand. They made mud pies which they used as missiles. I found it practically impossible to maintain any kind of discipline.

Then the headmistress called me to her study. It appeared that I had come within an ace of *murdering* the entire establishment. Large quantities of liquid clay had been thrown down the sink, the pipes were blocked. If this had not been discovered in time, typhoid would have been the result. Any number of staff and pupils might have perished and the fault would have been mine.

They were quite nice about it, everything considered.

Moral: *Don't pour liquid clay down the sink.*

VI *The workshop*

The bare essentials are: some clay, a good strong bench or table and a kiln or the use of a kiln. A detailed list of the things that you need will be found below.

You could make terracotta in your living-room but I doubt whether you could do it unless you were living alone. Better to arrange to work in an outhouse, or at least in some place where you can change your shoes on entering and when leaving the workshop, and to which you can bring fresh supplies of plaster and of clay. You will need running water. Your kiln will supply heat but you will need another heater of some kind. You are not concerned, as a painter is, with daylight. You should have electricity and several points.

I have made a sketch of a small workshop in a space (fig. 25), giving you a large door, a sink with draining boards above which you could have a shelf, and shelving along both sides of the room, leaving space beneath for dustbins which would contain clay, slip, dirty clay, plaster, sand, etc. By the window I have indicated a space for a revolving throne, but this workshop is almost too small for anything but a revolving chair. In the middle of the room is a table, one half of which is a plaster board, the other half is made of slate. The kiln is set at the far end of the room and opens towards the table. On one side of it is a panel for instruments, fuses, etc; on the other is a closet fitted with shelves and separated from the room itself by a sliding door, this to serve as a drying room. The floor should be of brick or cement. If the kiln be fired with gas or oil or any solid fuel, there will have to be arrangements for ventilation.

In addition to clay, a table and running water, a minimum provision of tools would consist of:

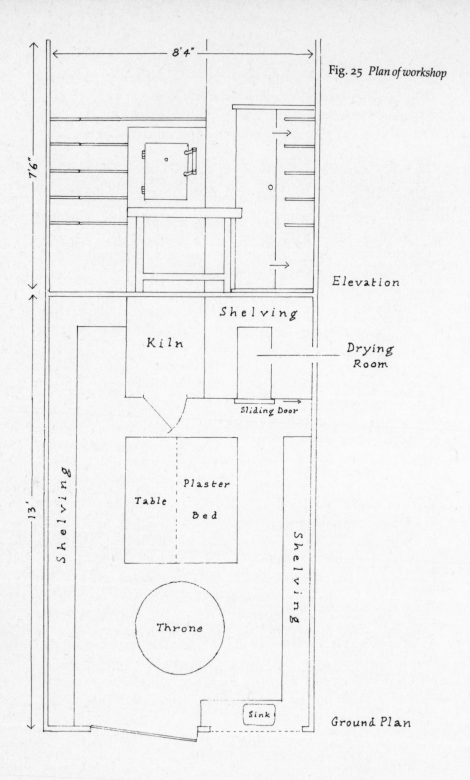

Fig. 25 *Plan of workshop*

8'4"

7'6"

Elevation

Shelving

Kiln

Drying Room

Sliding Door

13'

Shelving

Table

Plaster Bed

Shelving

Throne

Sink

Ground Plan

Abrasive tools, a penknife, supports, plastic bowls, brushes, callipers, dustbins, a file, a hacksaw and blades, a kiln, a lining wheel or modelling stand, loops, plaster, plaster tools, a few spatulate or wooden tools and some fine wire. (See index.)

A more complete workshop would probably contain the same instruments, but a greater variety of tools, as well as cement, containers (saggers), enamel colours (perhaps), needle files (certainly), a fixative spray, glue, grog, kiln furniture, metallic colours, modelling tools, oxides (i.e. colours), plastic bags, a pyrometer, resists, sand, sandpaper, sponges, a spoon, a steel palette, stuffing, supports, a model's throne (if possible), a vice, waterglass, water colours and a wide range of wooden tools.

Naturally the particular interests of the sculptor would lead to some additions and omissions. Such a list cannot do more than remind and suggest possibilities.

A list of possible tools could be much longer. There are many tools that you can make for specific purposes; there are also tools that can be converted to new uses. I have never actually used a corkscrew or a button-hook for sculptural purposes, but I can well imagine that they might prove very useful.

The beginner may ask, naturally enough, what are the most useful tools for modelling? The answer will depend on the condition of the clay that you are using.

If the clay be soft, wooden tools, loops, some wire for cutting clay and some slip for joining it will prove useful. It is pleasant to have polished boxwood, professionally made, tools, plaster tools made of good steel for scraping, spatulas, knives – discarded domestic knives can be excellent – and all kinds of metal tools for cutting and shaping. But you can make do with your fingers, some bits of wood and a knife to shape it with.

Most of these tools will still be of use when the clay is beginning to harden. A time must come when you can no longer model it with your hands; but you can always go on shaping it with abrasives and at the later stages with hacksaw blades, files,

rifflers, knives, sandpaper, pumice, etc., will always be useful.

It is not essential but it is very nice to have one of those small knives, the blades of which are very sharp and which can be replaced.

A SHORT BIBLIOGRAPHY

Dawson, Robert: *Practical Sculpture*, Studio Vista, 1970.
Drawbell, Marjorie: *Making Pottery Figures*, Tiranti, 1961.
Rich, Jack C.: *Materials and Methods of Sculpture*, Oxford, 1947.
Rock, Daniel: *Clay and Glazes for the Potter*, Pitman, 1957.
Wager, V. H.: *Plaster Casting for the Student and Sculptor*, Tiranti, 1954.

Glossary/Index
including essential and useful tools

This glossary/index is intended to serve two purposes: first the reader who wants to find the relevant article in the text will be guided to the section(s): the numbers below are section numbers unless preceded by the word page(s). Secondly, it is also a small glossary of potter's jargon in so far as it relates to work in terracotta.

ABRASIVES §§1, 13, 15, 19; pages 95, 97. *See also* Chalk-hard clay, Files, Fired clay, Graters, Hacksaws, Rifflers, Sandpaper, Steel palettes.

ACCIDENTS 11, 13, 38. *See also* Cement, Glue, Grog, Plaster.

ACRYLICS 19, 22. Here used to describe a kind of swift-drying, very durable paint or varnish.

ALTO RILIEVO *See* Relief.

ARMATURE 11, 12. An internal support or skeleton which lies within the clay model. Sculptors' merchants sell aluminium wire specially made for this purpose. The student is advised to keep his armatures as simple as possible. *See also* Supports.

BAIZE 12. Serves the same purposes as foam rubber. *See* Foam Rubber, Mat.

BAS-RELIEF (BASSO RILIEVO) *See* Relief.

BATT 12. A potter's term here used to describe any kind of stand, kiln-shelf, plinth or other support on which a clay model can be built.

BAYONET À FIXER *See* Fixative spray.

BISCUIT 14. A term used, paradoxically, to describe the initial firing or that which results from an initial firing in a kiln.

BODY 1, 2, 3, 4, 5, 6, 7, 41, 42, 43. A clay that has been prepared for use by the sculptor or potter. (*See* Daniel Rock, *Clay and Glazes for the Potter*, Pitman, 1957.)

BOLSTER 37. *See also* Sausage.

BOUCHARD *See* Hammer.

BOWL 29; page 97. Bowls are almost indispensable in the workshop. Plastic bowls are, I am sorry to say, to be recommended.

BRICKS 25, 26, 27. The bricks in question are toy bricks; real building bricks often prove useful in a workshop.

BRONZE *See* Metallic surfaces.

BRUSH 18, 20, 24; page 97. Obviously necessary for decoration, the Chinese brush, very full but coming to a fine point is excellent for most slip work and other forms of painting.

CALLIPERS (Dividers, compasses) page 97. Instruments for measuring distances. They consist usually of two arms joined by a firm hinge or screw. Callipers have curved arms so that they can measure the opposing points of a solid surface.

CAP 31, 33. A part of a piece-mould, usually a piece covering an area so defined that the plaster can be removed without damage to the clay.

CAST 32, 33, 34; page 9. The product of a mould, either a replica or the approximation of an object from which moulds, either of clay or of plaster, have been taken. *See also* Mould-making.

CEMENT 16. The cement here referred to is that which can be obtained from any builders' merchant (not *ciment fondu*), mixed with two parts of fine sand and moistened. Excellent for joining parts in large work, for mending, remodelling, or making plinths. Most cement cannot be fired but 'high temperature cement' is mentioned in dealers' catalogues. I have little experience of it.

CHALK-HARD CLAY 1, 13, 16, 39. Scratch a bit of clay and, if the scratch shows a lighter colour than the surface, the clay is chalk-hard and ready for pre-heating and firing. The clay is now very fragile; it can be worked and smoothed with an abrasive or a knife.

CLAY *See* Body.

CLAY RULER 11. An instrument for measuring the shrinkage in any particular body.

CLEATS 31. Convexities or incisions made in the side of a cap so that the various parts of a piece-mould will fit together. (*See also* Joggles, Keyways).

COILED FORMS 11, 26. A method of making hollow ware or sculpture which I describe but briefly because I, personally, have found it unsatisfactory. *See also* Container.

COLD CLAYS a new product (essentially different from terracotta), of which I cannot speak.

COLOURS 2, 9, 13, 17, 18, 23. *See also* Slip, enamel, oil, water colour.

COMPASSES *See* Callipers.

CONTAINER (Sagger) 14, 26; page 97. A vessel in which objects that are fired can be isolated and the effects of firing retarded and diffused.

COPPER OXIDE (CuO). *See* Oxide.

CUT 37. Here used to describe the divisions made in moist clay prior to firing; cuts are usually made because a piece is too large to go undivided into a kiln. Temporary cuts may also be made in order to make work easier, e.g. an arm may be amputated when in a moist state, modelled and replaced.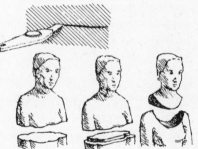

DAMPING *See* Plastics.

DIVIDERS *See* Callipers.

DRAIN (*also* Drainage) 37.

DRYING ROOM (Preheating chamber) page 95.

DUSTBINS page 97. Invaluable for storing clay, plaster or anything else that is affected by climate. Dustbins should be air-tight, hard rubber is better than metal.

EARTHENWARE *See* Terracotta, Grog.

ELEMENTARY WORK 1 For adults §§25–27. 2 For children pages 15–17.

ENAMEL COLOURS 23; page 97. Colours which can be painted onto the fired glaze.

EXCAVATION 12. The process of hollowing out clay sculpture while it is still moist.

EXTERIOR SUPPORTS *See* Supports.

FEATHER 33. The projecting film of clay which is left on the surface of an object which has been cast in slip; it lies along the lines of junction of a slip-mould.

FETTLE (verb) 33. To remove feather (see above) or other blemishes on the surface of a cast piece.

FILE 13, 15; page 97. Almost any kind of file is useful in the workshop, but the very small files called 'needle files' are particularly useful in working fired terracotta. *See also* Abrasives.

FIRED CLAY i.e. Terracotta 1, 9. Clay which has been fired to a point at which chemical change occurs, about 600°C. Fired clay cannot be restored to a moist condition; usually the colour changes and the body becomes hard and porous. *See* Terracotta. *See also* Grog, Biscuit.

FIRING 5, 10, 11, 12, 13, 14, 38. The process of cooking clay or of melting glaze upon the clay. *See also* Fired clay, Glost, Kiln.

FIXATIVE SPRAY (*Bayonet à fixer*) 20; page 97. A most useful device consisting of two metal tubes hinged together by a flexible joint. Any artists' dealer should stock them.

FOAM RUBBER 37. A sheet of foam rubber will support your model and, unless it be very moist, will hold without deforming a shape. It also makes an excellent base to a plinth and a packing material. *See also* Sausage.

FROST 38. A hazard in ceramic work. *See also* Waterproofing.

FURNACE *See* Kiln.

GLAZE 15, 17, 19, 23, 24. Any substance which can be applied as liquid to the surface of terracotta and will provide a finish, either matt or glossy according to taste, when fired. The number of different varieties that you can buy or make is enormous. Consult a dealer's catalogue and make tests. *See also* Metallic surfaces.

GLOST 14. The process of firing earthenware which has been treated with glaze, usually a second firing.

GLUE 8, 16. Any glue recommended for repairing china can be used. It is sometimes hard to hold an object in position when glued, so a quick-drying glue may be best. *See also* Slip.

GOLD *See* Metallic surfaces.

GOUACHE *See* Water colour.

GRATER 13. Those used in the kitchen and also the graters used by decorators are useful, particularly when the clay is chalk-hard. *See also* Abrasives.

GROG 4, 6, 16, 39; page 97. Terracotta which has been reduced to powder. It is sold but can easily be made by powdering and then firing chalk-hard clay. It acts as a refractory when mixed with clay; it can also be added to glue to give it body or powdered on joints in order to conceal repairs. *See also* Refractory.

HACKSAW 13, 37; page 97. Both large and small hacksaws are very useful in a workshop. The blade of a hacksaw makes an extremely versatile instrument for abrading or for decoration.

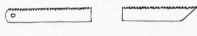

HAMMER Useful in a variety of ways; the so-called Bush Hammer or Bouchard has an uneven face which can be very useful in sculpture. Neither kind of hammer is an essential.

HEAT CRACKS 15, 39, 41.

HEAT INPUT REGULATOR 14. A device for governing the speed at which kilns grow hot.

JOGGLE (notch) 31. A v-shaped incision made in the wall of a plaster cap in such a way as to fit into a corresponding shape on the opposing wall, thus ensuring a perfect union between the plaster caps (*see* Keyways). *See also* Cleat.

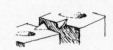

KEYWAYS 31. Perform the same function as Joggles (*see above*). They consist of convex shapes which meet corresponding concavities.

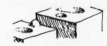

[103]

KILN (furnace, oven) 1, 5, 11, 14, 25, 41; page 95. A chamber of fire brick or other heat-resisting material furnished either with electric elements, gas burners or other devices calculated to heat the interior of the chamber to a high temperature. Kilns may also be heated with coal, gas or wood. The principle is that of the domestic oven but the kind of terracotta discussed here calls for temperatures far greater than those used in cooking food.

KILN FURNITURE There are many different ways of supporting glazed and unglazed ware in the kiln. For the sculptor the essential pieces of furniture are shelves and columns of various dimensions on which the shelves may rest.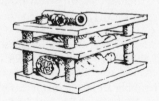

KNIFE 1, 13, 19, 27, 37, 38; page 97. A penknife or blade fitted to a handle is essential; kitchen knives, domestic knives, etc., are frequently very useful.

LAWN *See* Sieve.

LEAD KNIFE *See* Spatula.

LEVEL i.e. Spirit level, sometimes useful but not essential.

LINING WHEEL 20; (Whirler, Turntable) page 97. An implement intended for the potter but very useful to the sculptor. It consists of a flat disc which revolves upon a shaft; the shaft is set in a very solid stand.

LOOP 9, 18; page 17. (Wire-ended tool.) A shaft, usually made of wood, ending in a loop of steel wire, sometimes but not always circular and sometimes furnished with a serrated edge. With a little wire and some ingenuity they can be made at home. Loops are invaluable for shaping clay and can be used for abrading a moist surface. Some metal tools have a curved blade and, like turning tools, can serve some of the purposes of loops. *See* Turning tools.

LOOSE CLAY Potters' jargon for soft clay.

LUSTRE *See* Metallic surfaces.

MALLET 31.

MANGANESE OXIDE (MnO) *See* Oxides.

MASKING The use of some kind of masking material may be desirable if you are spraying on paint; there are various masking fluids on the market but I have not found them satisfactory with terracotta. I have used paper, polythene, lead foil and cardboard. I have also had good results using thin sheets of clay. *See also* Resist.

MAT (noun) 12. A mat of non-abrasive material is useful at the bottom of plinths which may, after all, be set upon someone's grand piano. Baize, velvet and foam rubber are all useful for this purpose. *See also* Sausage.

MATT (adjective) 15, 19. A quality of certain glazes which have little or no reflective power. *See* Glaze.

METALLIC SURFACES 24. The effect of gold, silver, bronze and lustre can be obtained in a variety of different ways. Gold, bronze and silver can be imitated by various water-bound paints. There are also various proprietary substances, particularly various forms of gilt polish. Gold, silver, lustre in liquid form can be applied to fired glaze and give a most convincing effect if fired to a temperature of about 700°C. These paints can also be applied in conjunction with a mixture of Copper and Manganese sprayed on to the terracotta and glazed; this in itself produces an effect very similar to patinated bronze. *See also* Oxides and Water colour.

MATRIX That part of a mould, which encloses the part that is to be copied.

MODEL Either a figurine, small sculptural work, or indeed any object which has been formed with an aesthetic intention, or one who poses for artists. *See also* Modello.

MODELLO 37; page 9. A sketch or project, here used to describe a scale model used in planning a larger work.

MODELLING TOOL (Wooden tool) page 97. Here used to describe the kind of tool which is used to press rather than to cut or scrape the clay. A great many types of modelling tool exist, including most of the wooden tools, but spatulate tools, knives, spoons and hacksaw blades can be used for this purpose. *See also* Loop, Plaster tool, Spatula.

MODELLING STAND page 97. A square metal or wooden plate made to revolve upon a tripod. Invaluable. *See also* Lining wheel.

MODEL'S THRONE pages 23, 95, 97. The type used by sculptors consists of a raised platform capable of accommodating a model, the floor of which is made to revolve. Very useful if you work from life, but expensive. A friend made me a very serviceable throne which consists of two wooden platforms one lying upon another, the two connected by a central shaft of metal. The upper platform is furnished with castors, the lower with a circular metal plate upon which the castors rotate; it works very well.

MOULD-MAKING 29–31, 32, 33, 34. Here treated under the following headings: Piece Mould, Press Mould, Slip Mould, Sprig Mould. *See also* Cast.

Piece Moulds 31. Moulds containing two or more interlocking pieces. *See* Fig. 16, page 73.
Press Moulds 34. The clay is pressed into one or more cavities to produce either a facsimile of the original or a hollow shape of approximately the same dimensions which will serve as a starting point for sculpture.

Slip Moulds 33. The slip is poured into a plaster container taken from the original model; it dries off upon the walls of the mould, thus producing an almost exact replica.
Sprig Mould 30, 34. A simplified form of press mould. The clay is pressed into the plaster cavity but left solid. The print is obtained by clapping the filled mould upon another piece of clay so that it leaves an identical image of itself in relief; it is then cut away with a wire.

NEEDLE FILE *See* File.

OIL *See* Resist.

OIL COLOUR A pigment which I have not used. It is used by some in order to conceal repairs.

OVEN *See* Kiln.

OVERWORKING 39. An accident which occurs when one removes too much clay while modifying a shape and breaks through to the cavity below. While the clay is moist this is easily remedied, but it can be hard to deal with if the accident happens when the clay is hard.

OXIDES 24; page 97. Ceramic colours of the kind which can be painted on to the unfired glaze usually consist of oxides. There is a fairly wide palette. Manganese Oxide (MnO) gives a very rich purplish brown, Copper Oxide (CuO) a very beautiful blue green.

PALETTE KNIFE *See* Spatula.

PEPLUM 37.

PIECE MOULD *See* Mould-making.

PLASTER OF PARIS (Fine Italian or Dental Plaster) 16, 28. Essential for mould-making. There are some new materials such as vinyl which I have tried, but without very good results.
(*See* V. H. Wager: *Plaster Casting for the Student and Sculptor*, Tiranti, 1954. *Also* Robert Dawson: *Practical Sculpture*, Studio Vista, 1970.)

PLASTER BED (Plaster board) 36, 42. A sheet of plaster used in drying out clay.

PLASTER TOOLS (Steel tools) pages 9, 97. Scrapers of various shapes made of metal and designed for working on dry plaster, but very useful in working on clay whether it be moist, dry or fired.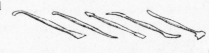

PLASTICS/POLYTHENE BAGS (Damping) 9. Plastic bags or, if you are working on a large scale, plastic sheeting will retain humidity and is much more effective than the traditional medium (a damp cloth), but to moisten damp clay use a damp cloth surrounded by plastic sheeting.

PLINTH 12. A base on which sculpture may stand and more particularly on which it stands when finished. *See also* Batt.

POLYSTYRENE 11. A synthetic material rather like a frozen sponge and very easy to cut. Respectable authorities recommend it for use as an armature. I have found that my body cracks up on it, but it can be used if wrapped in stuffing.

POLYTHENE *See* Plastics.

POLYVINYL ACETATE (PVA) 19, 22. Can be used as a medium, a varnish and a glue with terracotta.

PORCELAIN pages 10, 23. A very fine translucent body with which I have no concern.

PREHEATING CHAMBER 13. A chamber, usually adjacent to or actually forming part of a kiln, in which terracotta can be thoroughly dried out before firing. Useful, no doubt, but I find it sufficient to place ware on top of the kiln. *See also* Drying room.

PYROMETER 14, 41; page 97. A device for measuring the temperature within a kiln. Kiln-makers offer these together with many refinements of which perhaps the most important is a programming instrument which, at a given temperature, turns off the heat. *See also* Seger cones, Heat input regulator.

REDUCTION 34. The term, which has another meaning for potters, is here used to describe the process by which, using the natural shrinkage of the clay, objects can be reduced in size.

RE-ENTRANT FORMS 29, 32, 33. Any protrusion which leaves an undercut surface or is swollen so that its extremity would be trapped by the opposing surface is a re-entrant form. Thus a hemisphere or any lesser section of a sphere is not re-entrant and can be cast in one piece, but a shape like a pear or a doorknob, the surface of which is greater than a hemisphere, is re-entrant and must be moulded in more than one piece.

REFRACTORY 1, 2, 41. Substances which resist heat and are used to fortify bodies. They include Grog and Sand; others will be found in catalogues.

RELIEF 12. The term includes High Relief (*Alto Rilievo*), Low Relief (*Basso Rilievo*) and indeed *Mezzo Rilievo*, for which there is, I think, no English equivalent. Learned men who can measure the scale of projection can also tell you which is which; I can only guess. The interest of relief work for the beginner is that it lies midway, as it were, between drawing and sculpture, and therefore presents special problems of a most fascinating kind. Also, if you want to learn to cast, a very low relief makes an excellent starting point.

SILVER *See* Metallic surfaces.

SIZE 35. A retarding and fortifying agent for use with plaster; avoid cold-water size.

SKETCH *See* Modello.

SLIP page 19; 8, 10, 11, 18, 32, 33, 43. Liquid clay which can be used as an adhesive or a paint. Certain casting processes are made possible by using clay in the condition of slip. *Don't pour slip down the sink. See* Slip mould. *See also* Glue.

SLIP MOULD (Slip-casting). *See* Mould-making.

SPATULA (knife, kitchen knife, palette knife, penknife, paint scraper, etc.) A generic name for all these instruments which can be used to spread or flatten or cut clay or to clean surfaces.

'SPIDER' (four-legged spiders) 39. A device made of wire by which a hole in the side of the model can be filled from within and the filling held taut to serve as a backing for repair work.

SPONGES page 97. Both natural and artificial sponges are useful.

SPOON page 97. A spoon or a ladle is often very useful, particularly in casting.

SPRAY *See* Fixative spray.

SPRIG MOULD *See* Mould-making.

STAND The term is also used to describe the exterior supports which hold models and parts of models while they are moist. *See also* Batt and Plinth.

STEEL PALETTES page 97. Useful in treating fired clay. *See* Abrasives.

STEEL TOOLS *See* Plaster tools and Spatula.

STUFFING 11, 34, 37; page 97. Newspaper, lavatory paper, hay, straw, or anything else which will be at once firm and yielding when packed into the interior of a terracotta model and which will fire away without making a stink.

SUPPORTS 12, 37; page 97. Props made either of wood or of metal are placed either within a model to serve as an armature or outside as a crutch. *See also* Stands, Armature.

TANAGRA 18, 34. The name of a site in Boeotia, where many votive terracotta figures were discovered; later applied to all such figures.

TERRACOTTA i.e. cooked earth; also used to describe a colour, *passim*.

THRONE *See* Models throne.

THROWING A way of making pottery upon a moving wheel. A sheet of thrown clay may be used for lining a cast as an alternative to rolled clay.

'TIGHT' Potter's jargon for the condition of clay which is hard to throw because it is stiff; tight clay is suitable for modelling.

TOGGLES 9. Small handles of wood or any other material, which are fastened to the two ends of the piece of wire with which you cut clay. Toggles enable you to grip the wire; they also help you to find it when, as continually happens, it gets lost.

TURNING TOOLS Used by potters to fashion clay when it is cheese-hard. The type which is furnished with a sharp band of metal can be very useful when you are excavating a model.

VARNISH 21. There are many varieties, some matt, some shiny. Most varnishes will act as a waterproof. *See also* Acrylic, Waterglass.

VICE page 97. A large vice can be useful, particularly when you are working on fired clay.

WALL 29, 37. A mass of clay applied to an object from which a cast is to be taken; it serves both to resist and to retain the liquid clay from which a cap will be formed.

WASHING 41, 42. The process of turning clay into a very liquid slip and passing it through a sieve. (*See* Jack C. Rich: *Materials and Methods of Sculpture*, Oxford 1947).

WATER COLOUR (also Gouache) 19, 24. One of the most attractive media with which to decorate sculpture.

WATER-GLASS 21; page 97. A solution of silicate of soda or of potash sold by chemists for preserving eggs. Mix 50–50 with hot water; it acts both as a varnish and as a waterproof.

WATERPROOFING 21, 37. Essential if terracotta is to stand in the open. *See also* Waterglass, Varnish, Frost.

WEATHERING 6. The business of preparing a body for use by allowing it to stand in the open.

WEDGE 9, 31. Wooden wedges are set into piece moulds in order to make them easier to open; they are easily made.

WEDGING (fussing) 4, 9. Mixing clay. The method here described allows you not only to make the clay homogeneous but to remove air bubbles and foreign bodies.

WEEP HOLE 37. A drainage hole made in any part of a model which is likely to collect water.

WHIRLER *See* Lining wheel.

WIRE 9, 11, 30, 37, 39; page 97. Essential. A fine strong steel wire or copper wire will be best. *See also* Toggle.

WIRE-ENDED TOOLS *See* Loop.

WOODEN TOOLS page 97. There are many kinds and they serve many purposes; they can either be purchased or made. The best boxwood tools have a kind of purposeful elegance about them which makes it hard not to buy them. Many such tools have either a pointed or a cutting edge, others are furnished with a kind of knob for pressing clay into position, some have a serrated edge which is very helpful when the sculptor is attempting roughly to describe a shape. *See also* Loop, Spatula, Modelling tools.